SCHWIERING

AND THE WEST

BY ROBERT WAKEFIELD

First Edition

Library of Congress catalog card number 73-77752
ISBN number 0-87970-128-5
Manufactured in the United States of America

NORTH PLAINS PRESS
ABERDEEN, SOUTH DAKOTA

LIST OF ILLUSTRATIONS

All sketches included in the book are actual reproductions from Conrad Schwiering's sketch portfolio.

TABLE OF CONTENTS

VI.

TAPESTRY OF TIME. *Oil on prepared board. 48x48 inches. From the collection of The First National Bank of Rawlins, Wyoming*

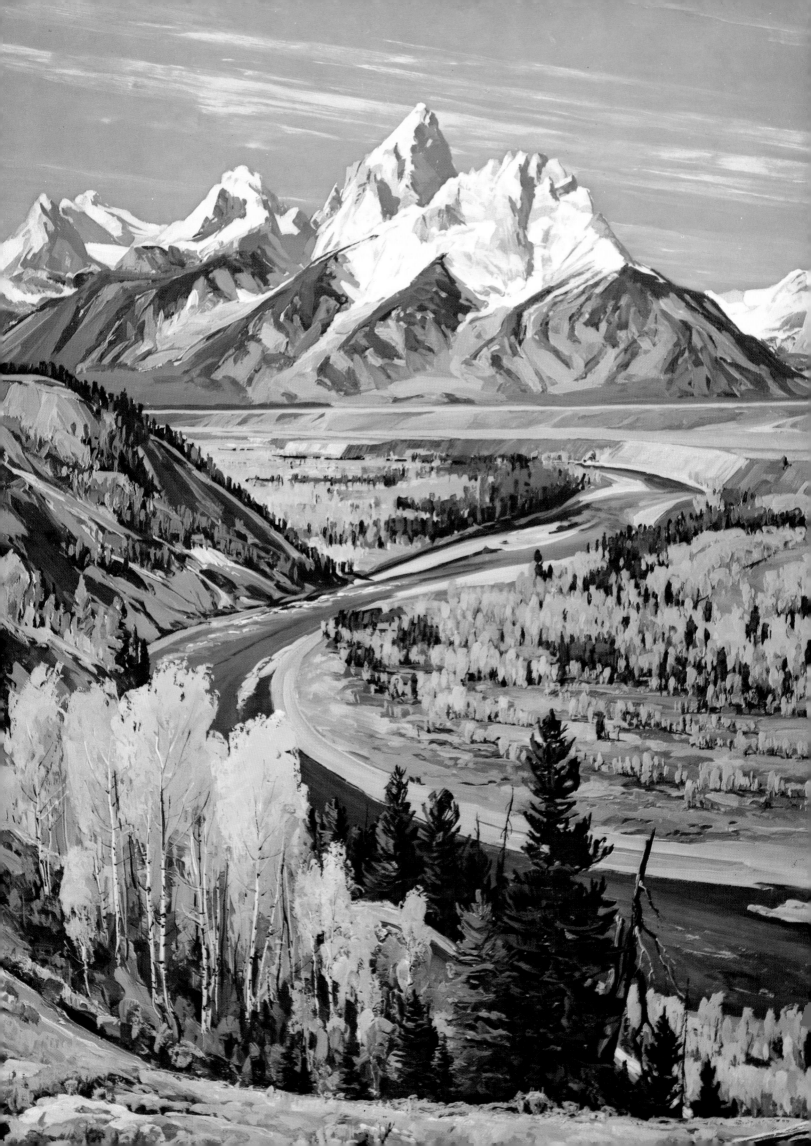

DEDICATION

To Sylvia and our sons, Todd and Mark

"A work of art is the trace of a magnificent struggle."

— Robert Henri

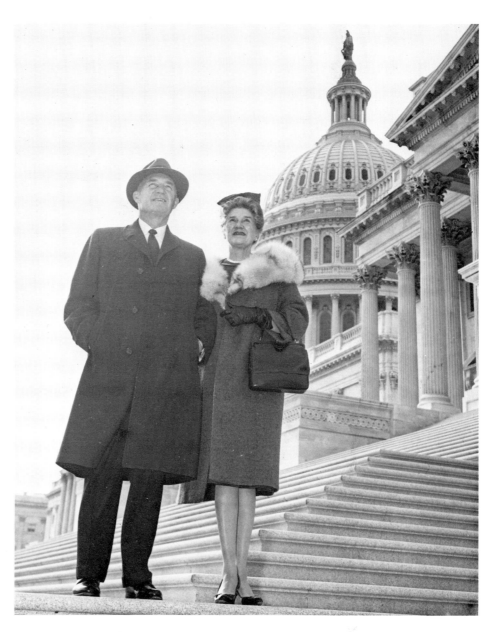

Former Senator and Mrs. Milward L. Simpson

XII.

FOREWARD I

Because of my long-standing, cherished friendship for Conrad Schwiering and his family, I consider it a rare privilege to have a part in this biography. Words cannot adequately express my admiration and esteem for my dear friend. Seldom has it been given to one so young to accomplish so much and achieve such fame in his chosen profession.

Conrad Schwiering was raised and educated in the Wyoming he loves. He is friendly, warm, and personable. As a painter he has captured the glorious majesty, the grandeur of the ever-changing moods of the Tetons—every nuance, every color, every hue. He is deft in touch and accurate and minute in every detail. His paintings reflect the bold imagination and great strength of the man. He strikes out like the master he is and paints with fervor because of the love of his subject and a justified confidence in a God-given talent.

Like many true artists, his eyes mirror his soul and his love of people. When you see that faraway look in his clear blue eyes you know he is dreaming up another vision of beauty to come to life on canvas. Those who live with his paintings can feel the soul tonic that seems to emanate from them.

Connie is a devoted family man. He and his beloved wife, Mary Ethel, do not lead cloistered lives. She is an inspiration to him in his work as well as in the many public spirited duties he so capably and tirelessly performs. Yet he is never too busy to assist and lend encouragement to young artists.

An interesting sidelight is the fact that his father, former Dean of the College of Education at the University of Wyoming, was a very able artist in his own right. Paradoxically, his son taught him to paint; the teacher became the pupil.

Perhaps because I was born in a log cabin at the foot of the Tetons I have a special love of Connie's portrayal of those spectacular mountains. I would not have you believe, however, that he is merely a painter of mountain scenery. He is a man of rare talent and has finished some very excellent character studies which are much in demand. He is constantly being importuned to paint more along this line.

Truly, in Conrad Schwiering, God gave us "a man to match our mountains."

Milward L. Simpson
Former Governor and
Senator from Wyoming

XIII.

Dr. Harold McCracken. (Photo courtesy of Bob Dorn, "In Wyoming Magazine.")

XIV.

FOREWARD II

The hallmark of a fine artist is not the signature he appends after the work is finished, but the quality of the work itself. Two of the most important attributes of a fine artist are a consistency of high quality, and a distinctiveness which makes it possible to recognize an individual's work without looking at the signature. This is true of such men as Remington, Russell, Bierstadt, and Thomas Moran; and for those who are reasonably familiar with their work, it can be recognized a long way off. These qualities are to be found in the paintings of Conrad Schwiering.

Like Moran and Bierstadt, Schwiering's realm is primarily the grandeur of the Rocky Mountains, in the midst of which he was born and has spent nearly all of his life. After graduating from the University of Wyoming he went East to study art under such great masters as Harvey Dunn and N. C. Wyeth. He learned a great deal, although his heart was always back home in the big mountains of western Wyoming. They have always been a part of him; and very few artists have put their majestic impact on canvas with more realistic fidelity and beauty.

Connie Schwiering lives in a big log home that he built himself, where the towering Tetons provide an ever-changing picture through the large front window — when the flowers make a colorful tapestry on the green foreground, and when it is far below zero with everything garbed in immaculate white. But it is not often that Connie has time to enjoy the picture through the window, because he is out studying the moods of the mountains, making sketches and then returning to put what he has seen onto canvas. This is why he does what he does so well. In addition, Connie is one of the most modest and nicest gentlemen-of-the-brush that anyone might hope to meet.

Dr. Harold McCracken
Director, Whitney Gallery of Western Art

XV.

The artist's wife, Mary Ethel Schwiering.

XVI.

DEDICATION

When you begin a life together, you have no idea of the amount of work that lies ahead. As times, good and bad, pass, you discover the strengths and weaknesses of your partner. Of course, I couldn't have done it if I hadn't had Mary Ethel's support, her whole-hearted encouragement, energy, and farsightedness, her labors to keep bread on the table when we didn't have any, her sticking with it when I was earning very little.

When you consider how long it took us to move from a trailer to our home; when you think about how completely I am dependent on her for all the details outside of my art — it takes an awful lot of stick.

You never know how lucky you are to have that.

Conrad Schwiering

A TIME FOR PLANTING

"I don't know what it is about the mountains. Somehow, from the very first they struck me with such awe and inspiration. How could man not feel belittled by their magnitude and mystery?"

From the moment he first saw the Grand Tetons, as a boy following his father on nature walks, Connie Schwiering swore he would some day say something about the beauty of the country. He knew that words were not sufficient to express his awe and humbleness in the shadow of nature's grandest eloquence. There was only one way he could convey to others the impressions he felt. That was by learning the language of nature and the language of art — and melding the two into paintings that would serve forever as statements. His early curiosity became an obsession, a desire to learn all there was to know about mountains.

The first person who recognized Connie's insatiable urge to learn was his father, Oscar Schwiering. Oscar's love and understanding of nature was passed on to Connie by "osmosis." Fishing trips became fascinating excursions through a living classroom, each marvel of nature noted by Oscar and impressed on Connie. Connie would lay his fishpole down and examine a flower or study a bird's nest. His father helped him understand the processes of nature — why and how nature flourished. As a landscapist later, Connie would demonstrate his intimate acquaintance with nature in his paintings, and each would serve as a kind of touchstone in the way that those boyhood excursions did. Throughout his life, Connie has insisted that nature be examined

1

with the enthusiasm of a child; only then can one truly appreciate nature's majesty.

Oscar Schwiering then was Superintendent of Schools in Douglas and Rock Springs, Wyoming. It was in Douglas that his son Connie first revealed his interest in art. He was barely able to walk when he found some crayons and drew pictures on the walls of his room.

"Mother and Dad referred to the incident quite often as I became more and more interested in art," says Connie. "You might say I showed an early interest in murals."

In 1924, Oscar Schwiering accepted a professorship at the University of Wyoming in Laramie. Five years later, on sabbatical leave, he moved his family to New York City where he studied for his Ph.D. at New York University.

While in New York, Connie attended Stuyvesant High, a competitive school where four out of five potential students fail a rigorous entrance exam. Part of Stuyvesant's curriculum was a required course in the fundamentals of drawing, which Connie found easy. He learned to draw in pencil, using such simple objects as books, inkwells, boxes and other objects representing basic shapes. Because of his skill, he was allowed to take the advanced class the following semester, where he learned the use of color. Those few months at Stuyvesant High concluded Connie's formal art training in high school. The family returned to Laramie, where Connie finished high school in 1934.

At the age of 17, during the Depression, Connie accepted his first job — dishwasher and stock boy at a small, local grocery store, The City Market. His first day on the job, his boss, Mike Christensen, grabbed him and spun him around.

"You see that lady coming in the front door," said Mike.

"Yes sir," said Connie, "sure."

"Let me tell you something, son," said Mike, "she's a customer. If she's not happy, you haven't got a job."

Connie, in his later years as artist and businessman, never forgot that lesson in customer relations.

In 1936, Connie's parents convinced him to study for a degree in commerce and law at the University of Wyoming, though Connie insisted he wanted to become an artist. He took all the fine art classes the University had to offer, but was disappointed to find the emphasis there was on non-objective painting.

"I was interested in painting mountains like I saw them and as I

2

Dean Oscar Schwiering, Univeristy of Wyoming.

Connie, 2 years.

Connie, 17 years.

Connie, 11 years. Brother Bill, 4 years.

The Schwiering family — Dr. O. C.; Mrs. Willetta; William; and Connie (lower right).

3

could understand them," he says. "I wasn't satisfied with making cubes and squares on a piece of paper without having them relate to something."

While in college Connie was a member of the ROTC program, and spent six weeks in infantry indoctrination at a camp in Spokane, Washington. After camp, he and four others chipped in for gas, climbed in an old Chevy convertible, and drove down the Oregon coastline. The trip took them past some of California's picturesque beaches to Los Angeles, across to Boulder Dam and the Grand Canyon, then back up through Utah and Wyoming. Never without his paint box, Connie worked while the others played.

"My pictures were pretty bad," he recalls, "but I kept trying all the time. Whenever we stopped long enough to make a sketch, I broke out my paint box."

Recognizing his son's talent and determination, Dr. Schwiering investigated the art field to see if there were any artists in the area who made a living solely from their art. He reached a depressing conclusion.

"In the Rocky Mountain region," he told Connie, "there isn't one man who's making his living solely out of the production of pictures — like you want to do. They're either teaching or involved in commercial art work, or they have a private income that is sustaining them. It's an awful precarious thing to get involved in."

"Dad knew I was bullheaded," says Connie. "He knew it was easier to convince me by letting me think it was my idea. Instead of shutting the door on my ambition to become an artist, both Mother and Dad encouraged me."

The Schwierings were proud of Connie's work and they took some of his paintings to Denver to have them framed. They asked a man at the Turner frame shop and art gallery whether their son had any talent.

"I think he has some ability," was the response.

"Could you recommend a teacher?" asked Dr. Schwiering.

"A man named Robert Graham over on Grant Street gives private lessons," said the man. "You might have your son get in touch with him." A chain of events began that spelled the end of groping, the beginning of a great artist's career.

When Connie found out about Graham, he made arrangements to study independently with him while he earned his degree at college. Robert Graham was a New York artist who came to Colorado because of failing health. Because so few people were buying paintings at the time, he was compelled to teach to survive.

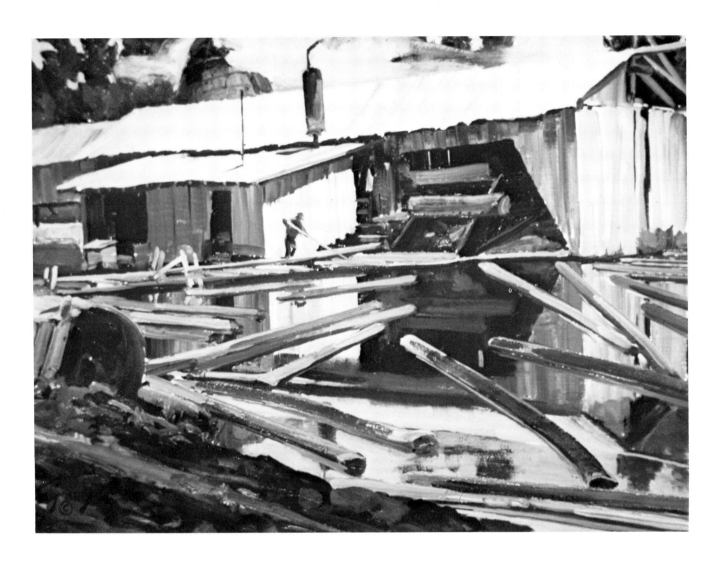

"Yachats Mill" 24"x36" oil on prepared board

American Legionnaires in convention occupied most of the hotel rooms in downtown Denver, so Connie carried his gear up the hill from the depot to Graham's home on Grant Street. Graham told him he could occupy a bed in the attic for his two-week stay.

Later, Graham and his student drove to the northwest outskirts of Denver, where the Flatirons of Boulder shimmered in the distance, with rolling hills and cottonwood trees in the foreground. Then came Connie's first outdoor painting with supervision and he was nervous. He walked with Graham to the spot where they would work.

"We'll set up and get you started," said Graham, "then I'll paint and you can refer to what I'm doing. That will help you think about what you want to do."

Working with Graham was good medicine for Connie. He created some landscapes that were the best he'd ever done. Afterward, filled with satisfaction because of the day's accomplishments, he found himself in the attic, alone with his thoughts and surrounded by many of Graham's finest paintings.

After two weeks, Connie returned to Laramie in a state of euphoria. His parents looked at his work and gladly consented when he asked to borrow the family car for weekend trips to Denver to continue the work he had begun.

Another artist made his mark on Connie. Raphael Lillywhite, a prolific western artist, worked in Laramie while his daughter attended the University. Connie sought him out at one of his art class demonstrations, and Lillywhite's style built a fire under him.

"I was excited about the way he worked," says Connie, "about the freedom and outdoors-feeling he got in his pictures. He tolerated me in his studio, just sitting behind him in his little room watching him paint, sometimes for hours. There's a lot of Lillywhite in what I do, because he caught my imagination."

Lillywhite was an impressionist but didn't know it. He painted scenes that represented the West he knew, because he didn't care for anything else. A true natural artist, his teachers were God and nature. But Lillywhite wasn't a good businessman. Often he sold his paintings for almost nothing simply because he was hungry.

Until he became a senior in college, Connie followed an intensive schedule as a part-time art student. Each Friday, after his last class, he jumped in the family car and drove to Denver. There he spent two days and an evening painting with Robert Graham and his other students before returning to Laramie and the University on Monday morning.

For as long as Connie can
remember, he preferred to
sketch, while others played.

Having a student from Laramie gave Graham a good excuse to paint the country around there — in company with his favorite student. He and Connie became good friends, and it came as a surprise when he announced his intention to close his studio.

"I'm going to live with my daughter in San Francisco," he told Connie. "and I want you to pick out something. Any prop that I have that you want, you take it." Connie looked around the studio, his gaze falling on objects he knew so well. There were many things that would remind him of Robert Graham.

"I'd like that," he said at last, pointing at an ancient Apache pitch water jug. Today it hangs in the corner of his own studio, a poignant reminder of those days when he was Robert Graham's student and friend.

Connie's quest for instruction and self-improvement didn't end here. He turned next to Bert Phillips, one of the five original New York City artists who founded the original Taos art colony. Phillips now lived in Taos, New Mexico, a secluded hamlet 80 miles from the nearest train. Connie hoped Phillips would work with him, and told him so in a letter he wrote just after graduation from the University of Wyoming in the summer of 1938. After Phillips wrote his okay, Connie borrowed his girl's car and made the long trek to Taos. His welcome was cut short.

"I'm busy, Connie," apologized Phillips, "and I've got a lot of things that have come up. I can't teach you, but I've made arrangements for you to go out and study with a man who is running an art school here."

Connie doggedly sought out the substitute teacher and signed up for his classes. After lunch, he broke out his gear and began to draw Taos Mountain and the Pueblos below in charcoal.

"You're seeing this all wrong," the instructor said. "The mountain is full of spheres and cubes and triangles and rectangles. It's made up of geometric forms, let me show you." The man sketched on Connie's board, then said, "Now carry on with this idea and we'll see how you go."

After the man left, Connie changed the drawing back to its original state. He was already exhibiting the fierce independence that marks a more mature artist. The man pressed the issue a second time, further riling Connie. When he returned, Connie had packed his gear and was ready to leave.

"Thank you very much," Connie said, "but if this is art, I am wasting my time. If you'll give me my money back, I'm going home."

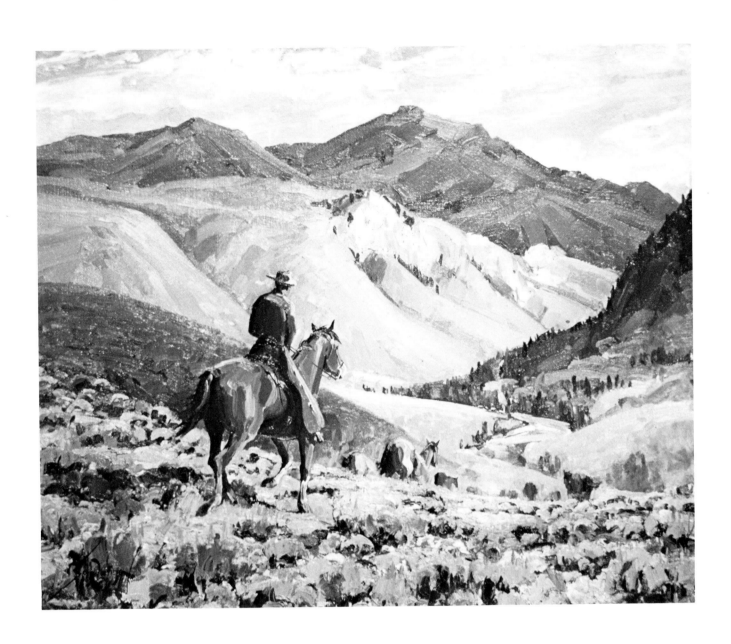

"Jinglin'" 30"x36" oil on prepared board

The chagrined teacher refunded his fee. Afterward, as a matter of courtesy, Connie revisited Phillips at his home.

"I quit the class," he said. "If that man is teaching art, then I'm wasting my time trying to be an artist, because what he had to say doesn't have anything to do with me. I want to learn how to draw and paint."

"If you feel that strongly about it," suggested Phillips, "you just go out and paint what you want to paint and bring it in to me." Connie stood dumbfounded for a moment before mumbling his thanks and leaving.

By eight o'clock the following morning, he had a picture ready for Phillips' critique. He stood patiently before the front door of Phillips' home and knocked twice, waited, then knocked again.

The artist rubbed his eyes, cinched up his bathrobe and motioned Connie inside. Connie carried his painting back to Phillips' studio and they spent a half-hour discussing it. Then he left and sought out another inspiration.

A prairie falcon arched its wings to catch a thermal current. Connie wished he could have been the falcon, seeing Taos as a dot in the upper center of a horseshoe formed by the mountains. Since it was still early summer, the tops of the 10 and 13 thousand foot mountains were still snow covered. His blue eyes searched the low foothills and he painted the juniper and pinion in his mind. He found a spot beside the glittering Rio Grande and painted a second picture. He finished it and retraced his steps to Phillips' home. After the critique and some sandwiches, he headed out to paint a third picture before the day ended. Late in the afternoon he presented his newest picture and an apology for his imposition.

"It doesn't bother me at all," said Phillips. "It's good to see somebody as hungry as you are." Connie told him about the doubts that had plagued him. "I suggest you think seriously about it," advised Phillips. "Paint on your own for awhile, try to develop as much as possible. Take as long as a year. In the meantime, get some brochures from all the art schools in New York City. Find the men you want to study with, then go back there and study with them, regardless of where they teach."

The month in Taos ended and he wheeled Mary Ethel Smith's Plymouth back to Laramie. He showed his paintings to his parents and told them about Bert Phillips' suggestion.

10 "Sounds good to me," said his father.

Another year passed. Connie built a file of art school brochures, took some law courses at the university, painted steadily — and asked Mary Ethel Smith to marry him. The marriage took place in Boulder, Colorado, September 1, 1939.

The honeymoon was a cross-country trek to New York City, where the newlyweds made their first home.

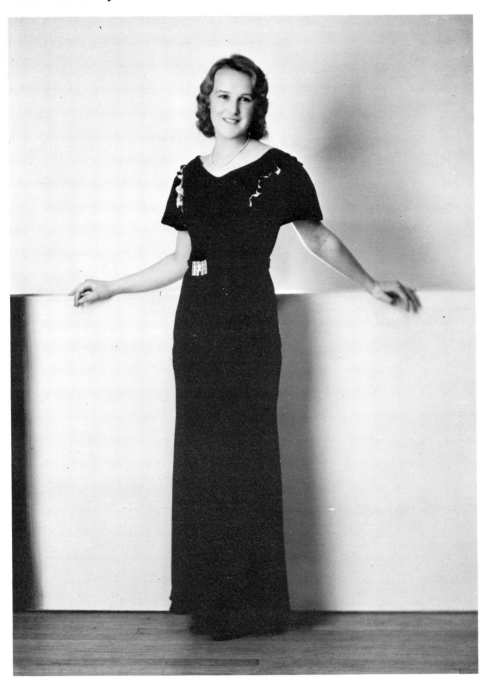

Mary Ethel Smith, named "The Most Beautiful Girl at the University of Wyoming," by the late Cecil B. deMille.

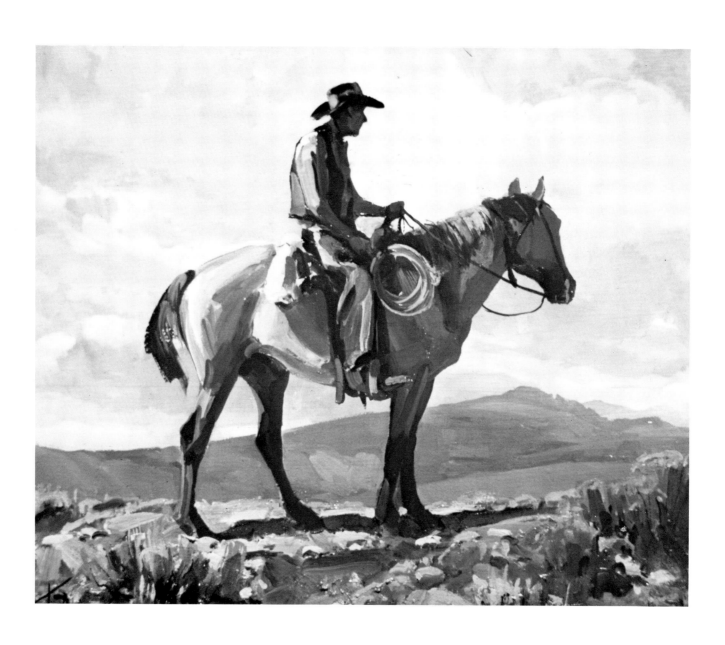

"Old Timer" 25"x30" oil on prepared board

CHAPTER TWO

A TIME TO GATHER STONES TOGETHER

Hitler sent his troops across the Polish border the same day Connie and Mary Ethel were married. During the week that followed, America's role in the conflict was the dominant topic of conversation as they drove across the country. Connie had just been commissioned in the army and they both knew it was just a matter of time before he would be called to active duty.

"You start looking for Broadway," he told her as they emerged from the Hudson River tunnel. With equal parts of grit and confusion they found Broadway and headed uptown toward the Art Students League. There they found a listing for a prospective apartment and returned to the car. The first shock of driving in the city had worn off and Connie drove more confidently. They went up Fifth Avenue beside Central Park as far as 88th, where Connie turned in. A cab driver let them know they were going the wrong way on a one-way street. The kids from the sticks had arrived in the big city.

The Art Students League was Connie's second home. If you were to name a great American artist, the chances are good that he or she studied at the League. Dirty, smelling of paint and turpentine, it was a haven of greatness. You are not given a degree for your work at the League — you go to the League to become an artist.

Charles Chapman was typical of the high caliber of League instructors. He had won the Saltus Gold Medal twice, once with "In the Deep Woods," now in the Metropolitan Museum of Art, and the other with "The Escape." He had won the Altman and Carnegie prizes twice,

as well as awards at the Salmagundi Club. His credentials included prizes from the Art Students League, the Chicago Art Institute, the Philadelphia Art Institute, the Metropolitan Museum of Art, the Minneapolis Art Museum, the Syracuse Museum, Artists' Professional League, Montclair Museum, and many more, including the President's prize at the National Arts Club. Chapman was a National Academician when Connie met him.

"I want to learn the fundamentals," he told Chapman. The tall, slim teacher poked a cigarette into a pipestem holder and spoke quietly.

"I had a little old lady in one of my classes for four or five years," he said. "One day she came up to me and said, 'Mr. Chapman, I'm very disappointed in you and your class, and I'm going to quit.' I asked her what was the matter and she said, 'I see these young people come to you and work with you, and in a year or so they get it. You give them the secret of art, but you've never given it to me.' " Chapman lighted the cigarette and continued. "Apparently, the lady came to the League expecting art to fall out of the sky. Like so many people, she was looking for a pat formula to answer her problems. Art isn't full of pat solutions, it's full of experimentation. And it's full of an intelligent evaluation of your steps as you go. This is the realization that the aspiring student must have. I could only tell the poor lady that I was sorry."

Connie signed up for cast and life classes with George B. Bridgman. Bridgman was a disciple of Michelangelo and had been teaching the principles of anatomy at the League for more than 30 years. In his cast class, students were taught the basics of human anatomy and drawing. Plaster copies of the great sculpture of the ages were taken from their place of storage and displayed on a stand high above the students' heads. There Connie and his classmates learned the rigid discipline of accurate drawing, working from copies of great sculptures by such masters as Michelangelo, Donatello and Rodin.

Like a classy showman, Bridgman used a big blackboard and a four-foot extension chalk holder to demonstrate his lessons. Beautiful and detailed examples of anatomy flowed from the tip of the chalk onto the board. As a doctor might, he noted details of the reaction of bones and muscle. Bridgman showed them how to appreciate deeply the human machine. Because he identified so closely with Michelangelo, he often referred to the Italian genius during his lessons. His own masterful drawings communicated his feelings with great authority.

In his life class, nearly 50 artists tried to work at the same time. Bridgman patiently critiqued each student's work, making comments and drawing beautiful, rhythmic sketches of the model. Each time he

neared, Connie wished he could have disappeared beneath the floor-boards. After sweating it out for three or four weeks, Connie told Bridgman how inadequate he felt.

"I don't know what I'm doing in here," he said. "I just don't seem to be getting a hold on the drawings. I can't get this beautiful rhythm of form and line that you can see and do so easily. I suppose I ought to be back in the cast class."

"That's the best decision you've made in your life," said Bridgman, shutting Connie's sketch book. "Go back there right now." Connie left the life class for good.

Bridgman, he learned later, favored the students in the cast class, feeling that those few students — 15 as opposed to 50 — were really trying to learn to draw.

Connie learned early that his studies didn't merely involve classroom sketching. He cringed one day when Chapman asked to see his sketch book.

"What sketch book?" he asked.

"Don't you have a sketch book?" repeated Chapman, a bit miffed. "Aren't you sketching?"

"I don't have time to sketch," said Connie. "I'm busy in class all day, and I got a job at Schrafft's that keeps me busy until one or two in the morning. When do I have time to sketch?"

"What do you do when you ride in the subway?"

"You don't mean that I should sketch in the subway," replied Connie, "with all those people around?"

"You're going to have to get used to people," said Chapman, "and you might just as well start now."

Connie carried a sketch book from then on. Chapman gave him a group of sketches by Dean Cornwell for inspiration. He was ready the next time Chapman asked to see his work.

"Why are you just doing vignettes?" said Chapman, mildly explosive. "Why aren't you filling space? Why aren't you making an arrangement that's interesting? You just can't leave everything out. This isn't the way you're going to work throughout your life. If you're going to paint easel pictures, you're going to have to decide how every inch of the canvas is to be treated. Right now," he concluded, "you ought to be thinking about filling space — in every sketch — so that the space you design for your drawing is carefully chosen. That practice is going to be invaluable to you."

15

Schwiering's early training in anatomy helped him in his later studies of the animal form.

Connie learned early that an artist should carry a sketch book with him at all times.

Connie soon learned to ignore the comments and stares from people on the subway. Whether his subject was a lady across the aisle with an interesting fur muff or a man with a funny hat, he tried to fill space with interesting material. Chapman looked over his work every two or three weeks, not as interested in how well Connie made his statement as in how well he planned and thought it out.

"I want you to paint a picture in your mind," he advised. "Find the salient features. Think about how you handle the paint to convey the information. Design your pictures. You can paint thousands of pictures that you may never get a chance to actually execute. Your mind will encompass the problem and solve it — where your fingers can't. To solve the problem, you get the two working together." Connie began to get the habit.

Chapman's class met in the afternoon and taught students the fundamentals of painting and design. It was a general class, designed for all kinds of artists at all different levels. Most of his classmates, however, were beginners like himself.

The students painted from models, both costumed and nude. Chapman never lectured his class, but was present every Tuesday and Thursday for individual critique. He was a severe critic, especially with his advanced students. Whenever he spoke, everyone listened.

Connie usually hid his brushes out of sight whenever Chapman approached, because he didn't want Chapman to paint on his pictures. But Chapman always stepped right up and said, "Well, all right, Connie, let's get out a nice big brush. You're working in too much detail." Chapman's emphasis was on simplicity. An artist should work in bold suggestive strokes, not in tiny detailed ones.

After a month in a bug-infested apartment, the Schwierings moved to Leonia, where Howard McCormick provided a small apartment in his home. Charles Chapman had introduced Connie to McCormick, an expert wood engraver.

The young artist followed a grueling schedule. He was appointed monitor in George Bridgman's cast class, and the job paid the tuition for the class. He arrived at the League about 7:30 each morning to set the cast class up. His lunch was a sandwich and an apple from home, usually washed down with a quart of milk purchased at a little store on 57th street, near Carnegie Hall.

Connie's class with Chapman lasted the better part of the afternoon and gave him just enough time to catch 40 winks in the library prop room before reporting to his cashier's job at Schrafft's. There he earned 50 cents an hour, working from six until well after midnight. About one a.m. he boarded the Eighth Avenue subway and

Preliminary sketch for artist's painting "Quittin' Time."

QUITTIN' TIME. *Oil on prepared board. 30x40 inches. From the collection of Mr. & Mrs. Gordon Mickelson, Big Piney, Wyoming*

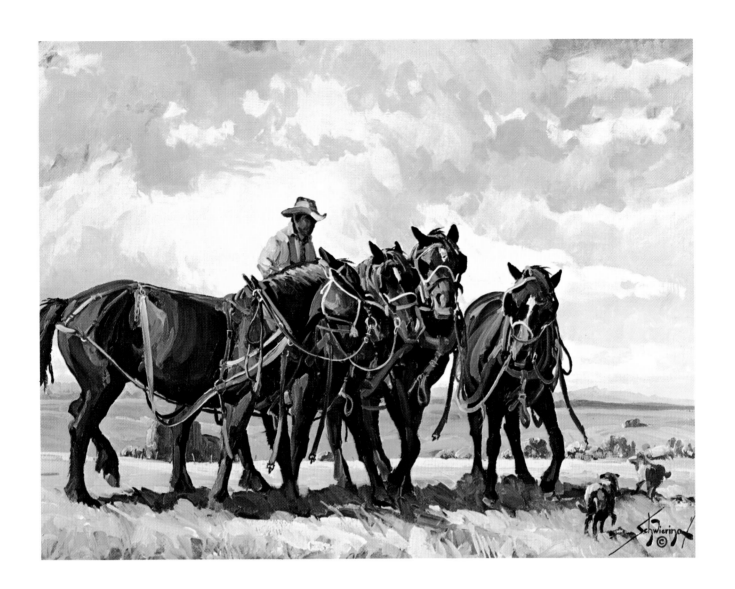

rode to the George Washington Bridge where he caught the bus to Leonia, New Jersey, usually crossing the doorjamb of their apartment about two. This rigorous schedule was repeated six days a week.

Lack of money wasn't the Schwierings' main problem. Mary Ethel worked as a secretary and they averaged $30 to $35 a week between the two of them. Their hangup was time. Since Connie was at school all day and at Schrafft's most of the night, their time together became a precious commodity. On his days off they visited museums or went to the movies.

After they had been in New York for a few months, Connie began to be plagued by self-doubts. He felt he wasn't progressing as fast as he should.

"I'm doing miserable work," he told Chapman, "I'm just not learning as fast as I want to learn." Chapman puffed on his strange cigarette holder and listened patiently. "Today, after my work was critiqued, I got to thinking — now, this is the same critique that I got last week. I made the same mistakes last week. Why in the hell am I so dumb that I can't apply the principle everywhere in the picture? Why is it so hard for me to realize that the principle applies in many ways, not just in one way? I'll never learn it. I'm so dumb I'll never get this stuff organized."

"I assure you it isn't a mystery," said Chapman. "It's a basic principle and you have to learn that it applies in more cases than one. Nothing about art is a mystery. You'll learn, Connie, if you apply yourself and learn the fundamentals."

Confidence gradually replaced Connie's self-doubt. He began to realize that, even though his painting might fall short of the masterpiece he had hoped for, it was a step in that direction. Mary Ethel helped him keep his bearings. She never mentioned the hardships and never suggested he give up his dream.

During the summer of 1940, the Chapmans let Connie and Mary Ethel use their home, while they vacationed in Morristown, New York. Connie used Chapman's studio during the day and began to cultivate illustrations for western pulp magazines. The walls downstairs were covered with originals by many of America's foremost artists — works which Chapman had obtained by swapping pictures with his contemporaries. He hung his own works on the walls beside the stairs and in his large studio. The creative atmosphere helped inspire Connie. Though he felt, because of his western heritage, he had an edge on most of the artists who provided illustrations for the pulps, he soon was to get his first taste of rejection.

After his shift at Schrafft's, he was anxious to get home, since it

was his birthday — August 8, 1940. He carried a bunch of 24 by 36-inch illustrations ("Not quite what we've been looking for," an editor told him that day) and was in a hurry since his train was pulling into the station. He ran, forgetting the awkward boards and, tripping over them, fell to the concrete platform. The worst damage done was a huge rip in his pants — a loss that would take a week of work to replace. Dejectedly he mounted the front steps of the Chapman home and opened the door. Though it was about two in the morning, Mary Ethel greeted him with a birthday cake bearing 24 lighted candles. He was further cheered when she told him that the pants were not lost, but could be easily mended.

Earlier in 1940, Connie and "Uncle Charlie" Chapman went to a showing of water colors by members of the National Academy. A water color by Walter Biggs particularly impressed Connie. The picture showed a southern town at night, and it was full of mystery.

"This man is a great artist," said Chapman. "He's a fine illustrator and he teaches. You should make arrangements to take some classes with him."

Connie waited until the fall of 1940 to sign up with Biggs, who taught illustration at the Grand Central School of Art. As a critic and teacher, Biggs' approach to his students' work was much different than anything Connie had ever known. Chapman and Bridgman were direct and forceful in their approach, while Biggs was a "tender" sort of teacher.

"That's very fine, the way you're going," he told Connie one day. "It could be improved if you carried a continuity of color behind the figure." Connie wasn't used to the subtle approach, and he told Chapman.

"His crits aren't sinking in," he said. "I just don't catch them."

"You have to listen sharp when that man talks," said Chapman. "When he makes a suggestion, it's like me saying 'You're all wrong.' You've got to consider that he means it harder than it sounds. He just doesn't have it in him to hurt anybody's feelings."

Biggs could be brutally truthful on occasion, Connie discovered. A skinny fellow with stringy hair and kind blue eyes, one day he examined one of Connie's paintings and said, "Well, remember son, Rembrandt used to think he was lucky if he got one in ten."

After class was over at four in the afternoon, Connie cleaned up and went down through Grand Central station and up on the other side into the Galleries, where he browsed until closing time. The Galleries always exhibited the best American painters, and the young art student

23

BRUNCH. *Oil on prepared board. 30x36 inches. From the collection of Mr. & Mrs. Jack Rosenthal, Casper, Wyoming*

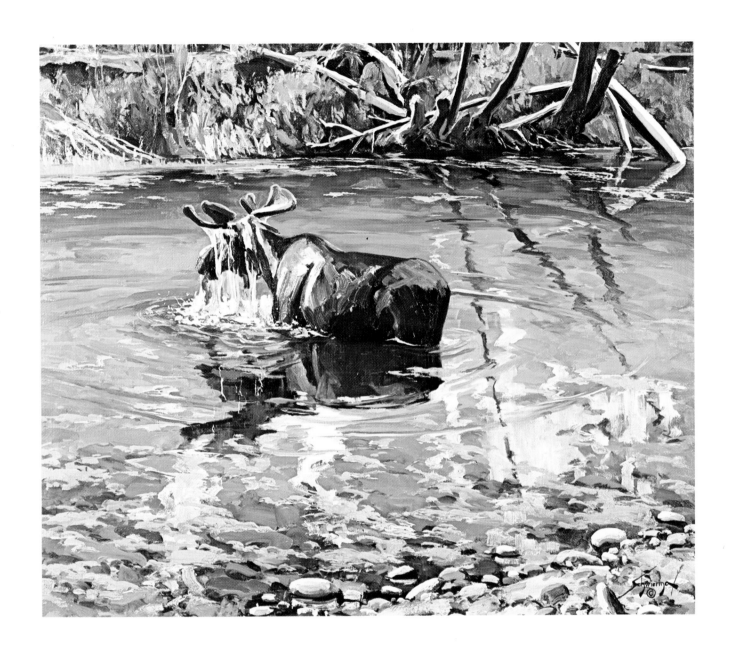

spent hours reflecting on the works of Chauncey Ryder, W. R. Leigh, Frederick Waugh and others. The staff at the Galleries knew he wasn't a buyer. Often they would tell him about a new picture and bring it out for Connie to see. He learned that the Galleries had sold more than one million dollars worth of Waugh's paintings during his lifetime, a world's record at that time.

Connie worked with Chapman at the American Museum of Natural History during his free afternoons. He helped paint the Puma Habitat Group in the North American Mammal Hall of the museum. Work on the Grand Canyon scene taught him how to properly fill large spaces.

Over at Grand Central he worked with an illustrator who forced his students to produce pictures that held together and carried the weight of inspiration and design. Biggs used models extensively. One week the students painted a Persian dancer, the next week a shepherd, then a ship builder. Most of the material came from the artists' imaginations.

Chapman taught Connie the importance of understatement in a picture by telling a story about his friend, Frederick Remington. Chapman visited Remington often at his Ogdensberg, New York, studio.

"I watched Remington work on an illustration involving one of those big, high-wheeled bicycles with the little wheel in the back," he said. "The rider was going down an incline — but Remington didn't know where the pedals were, so he painted dust up over it." Remington faced other problems, Chapman declared. "He had trouble with color, so he experimented all the time." Uncle Charlie discounted the theory that art is a God-given gift. He said, "God doesn't walk around and tap people on the shoulder and say, 'You I make an artist, and you are a bricklayer, and you I make a ditchdigger.' The will and desire of the individual make him into what he wants to be, that's the God-given gift."

At the end of the year, the student body gathered at the Grand Central Galleries for informal recognition ceremonies. Walter Biggs took the podium and announced, "The Medal of Merit goes to a young artist who exemplifies the highest standards of the Grand Central School of Art, O. Conrad Schwiering, or 'Connie' as we know him."

Connie accepted the award, stunned.

Afterward, Uncle Charlie congratulated him and offered the key piece of advice that influenced his career from that time forward. They sat in Chapman's studio.

"Do you want to be a professional student?" asked Chapman. "Or become a kind of protege of Charles Chapman? Go through the National Academy routines? Or do you want to be an artist, like you said when you first got here?" Connie looked at him.

"I want to be an artist," he declared.

"Well, you can stick around here for another year," said Chapman. His hand stabbed the air for emphasis. "You can win these prizes, the trip to Rome and travel to Europe — if that's what you want to do." He pushed a cigarette into his strange pipestem holder. "But I thought you told me you wanted to paint your country." He struck a kitchen match.

"That's right," said Connie.

"Then go," said Chapman. "You've got the fundamentals. Go home and paint by yourself and develop by yourself. Go paint your country."

In the early summer of 1941 they went home.

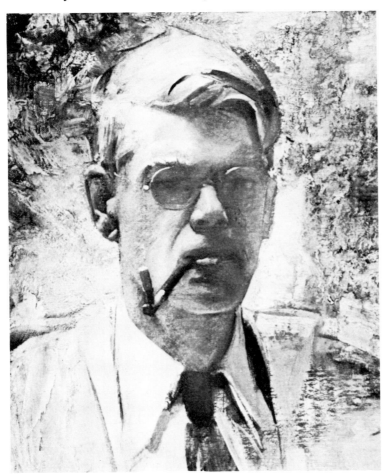

The artist's mentor, Charles S. Chapman, "Uncle Charlie". Self-portrait.

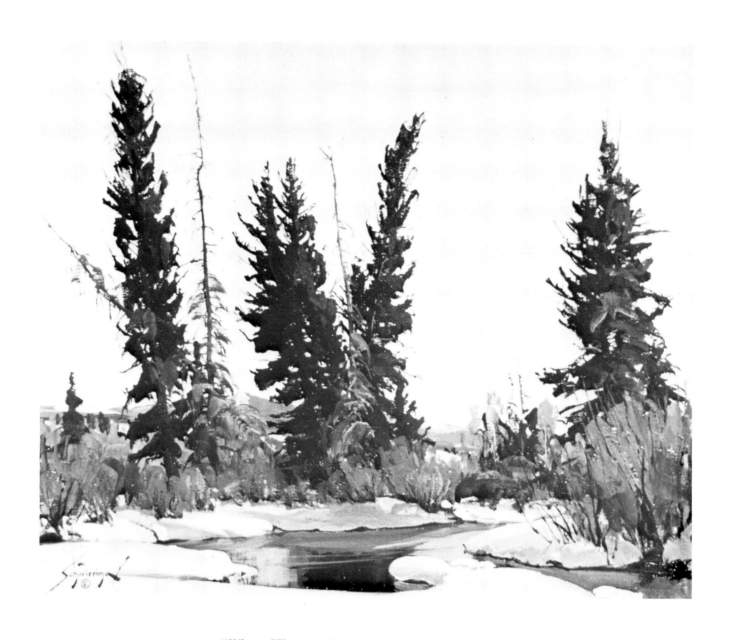

"Winter Silhouettes" 25"x30" oil on prepared board

CHAPTER
THREE

TIME OUT FOR WAR

They knew what was coming. In the fall of 1941 Connie reported for active duty at Fort Benning, Georgia. As a First Lieutenant in the visual aids section of infantry school, he supervised the production of film strips for troop information courses. He wrote the narrative material, directed photographers and models, and supervised half a dozen artists in retouching the layout work. In addition he gave lectures to officer candidate classes on the use of visual aids.

When a directive was issued transferring those officers with more than 18 months' time at the infantry school, Connie was sent to an engineer camouflage battalion newly activated at Fort Carson, Colorado.

At Fort Carson, just south of Colorado Springs, he continued painting in his spare time. He took paintings to Denver trying to make some sales, stopping first at Cyrus Boutwell's gallery on Broadway.

"I'll tell you, young man," said Boutwell. He picked a painting of a cattle drive with Pike's Peak in the background and said, "I think I could sell this picture, but I can't get the price you want." Boutwell gestured at the $400 price tag. "How did you arrive at that figure?" he asked.

"I checked what other artists are charging for their work in the big shows," said Connie, "and frankly, I didn't think I priced it very high compared to them."

"In the first place," said Boutwell, very sincere, "you've got to

29

realize that most of these national shows sell almost nothing. Many of the paintings are taken by museums, but usually for less than the artist wants. Now, I could sell your picture, if you'd let me sell it at $200."

Connie bit his lip and thought a moment, then left the painting. He was in, accepted by one of Denver's leading art galleries. He went to the *Denver Post* to see Paul Gregg ("I grew up on your Sunday pictures," he told Gregg the first time they met). Gregg introduced him to managing editor Alexis McKinney, and the meeting resulted in some publicity for Connie's work at Boutwell's.

Two weeks later, Boutwell sent a check for the sold painting, but Connie's joy was short-lived. The army ordered him to report for maneuvers at Lebanon, Tennessee. He didn't see Denver again until the war ended.

Connie's 606th Engineers acted as advisors for the "aggressors" and regular troop-trainees. Connie was executive officer. One day Division Headquarters called him in for a special assignment.

"My division lost 22 men last night during a river crossing," said the commander. A mixture of sadness and determination clouded his voice. Connie sat down, shocked. "It's your baby. I'm putting the 606th in charge of body recovery." Connie wished his battalion commander hadn't taken sick leave the day before.

He went to the old-timers along the river for advice. "We don't have these big, wide rivers in Wyoming," he told an old man, "and I don't even know where to begin."

"Quit lookin'," the old man said. "They won't bloat and rise until the river's temperature rises, so you might just as well quit lookin', it's just a waste of time."

Regardless, Connie's engineers worked the river with grappling hooks, facing danger themselves because of the high water. Every day for 23 days in a row, Connie logged the river bottom's temperature. It finally rose, and within two days bodies began appearing downriver. The old-timers were right, and Connie's 606th Engineers recovered the bodies of all 22 soldiers.

Afterward, the commanding army engineer promoted him to Assistant Engineer for the Second Army. In Memphis, Connie handled all engineering personnel dispositions for the Second Army.

Lt. Col. Conrad Schwiering left active duty in February, 1946, and he and Mary Ethel returned to Laramie to sort out their lives. Behind were years of patient waiting. They were alive, together, and home. The rest of their lives would be a kind of bonus, and they wanted to make the most of it.

Two places beckoned, Arizona and Jackson, Wyoming. Their compromise plan called for summers in Jackson and winters in Arizona, with a home on wheels. They bought the trailer and a dog named Dusty in Denver, enthusiastic about the venture that lay ahead.

Connie installed a hot and cold water system and a flush toilet. A generator provided electricity. With a gas stove and refrigerator completing the trailer's interior, renovation cost them about $5,000. To pull it, all their faith was put into a 1936 Plymouth sedan, the car that had carried them all over the country. To ease the weight on the car's rear wheels, Connie fitted a dolly between the trailer and car. Electric brakes were added as a final touch, and in September . . . on to Phoenix.

About seven miles outside Laramie, trouble hit. Down a small incline Connie hit the foot brakes, from reflex, instead of tapping the electric brake switch with his hand first, and the trailer fishtailed.

"There she goes," said Connie, helpless. The trailer wrenched free of the car and fell on its side in the borrow pit. They had waited five years, and their new home lay in shambles beside the highway. As they stood there numbed, a good samaritan promised to send a wrecker. Another bystander, a trailer dealer from Greeley, offered Connie $2,000 cash, which he refused.

They followed as the trailer was towed back to Laramie, looking in horror at the shambles of their new home. A celebration cake was splattered from cupboard to ceiling and floor. Mary Ethel cleaned up some of the broken glass, but shards were everywhere, and the truth was known — renovation was going to be a long and difficult task.

Electrical wiring, water and gas lines were intact, but cabinets shifted within the trailer and most of one side was dented. Winter blew in before the job was done, and sadly, they realized it was too late to go anywhere. Connie built a lean-to porch beside the trailer and painted his pictures there. Income this year, however, came not from painting pictures, but houses.

The following June they borrowed a truck from the University to pull the mended trailer, and Jack Ruch, Connie's brother-in-law, offered to drive it. The artist and his wife followed in the Plymouth. Their destination this time — Jackson Hole, Wyoming.

Once again their journey was not without disappointment. The hitch broke at their first stopover in the middle of the Red Desert, as Jack pulled off the highway into a parking lot. A mechanic welded it back while they drank coffee, only to have it break again in Pinedale. A Pinedale mechanic fixed it, and once again they were on their way. On June 7, 1947, Jackson Hole's newest residents arrived.

They didn't stop in Jackson, but drove a couple of miles past, to where the Spring Gulch road bisects the highway that eventually strikes the Idaho line. There they spent the next five or six days confined by a torrential rainfall.

Cabin fever got to Connie, and he drove a short distance up Spring Gulch road to the Hansen place. Cliff Hansen and his wife, Martha, welcomed him with customary warmth, and the two old friends took a drive in the rain and mud. Connie looked at the cattle, the misty hills and mountains, recalling early Teton memories that later were to appear in his paintings. He was back in his element, and it was exhilarating.

After the rains, they rented a lot from Cleo Karns next to the Quality Cleaners in Jackson. Connie visited next door, at the rambling home of Dr. Floyd and Gladys Naegeli, the dentists. "We only plan to be here for the summer," he told them.

After they moved the trailer onto the lot, Connie dug a cesspool, ran water lines and electric wiring. He built a lean-to for himself and a dog house for Dusty. Their trailer rested on an old river bed which, were it not for Connie's quick work with a shovel, would certainly have inundated them with the next big rain flood.

With the months of summer ahead, Connie swore he was going to solve all of the mountains' problems and turn out the greatest of masterpieces. He had been held up by four years of college, five years of army, a year beyond that, and now he was ready. But with all his past training, and all his present enthusiasm, Connie was totally unprepared for what lay ahead — a formidable sight — the Grand Tetons.

His first attempt at the Cathedral Group "was just like diving into the Grand Canyon from the rim. It was a completely herculean mountain mass, and I was at a loss to come to grips with it." After worrying about getting the scale of the country in his paintings, he worried about getting "the information about the mountains" in his pictures. He admits his first attempts were overworked and overspelled, "as though a chicken had walked over them."

Connie set up his gear on the town square, where he hoped to attract a buyer. He shunted interested passersby down to the trailer, where Mary Ethel exhibited his canvases. In theory the plan seemed workable. Day after day he painted on the square, from about four in the afternoon until dark. He talked with a lot of people, but sold nothing. Then he remembered Robert Graham's warning — art is a harsh mistress . . . if she ever got you, she'd never let go. He believed it that summer.

George A. Dick of Manitowoc, Wisconsin, came by one lovely morning and Connie showed him some of his paintings in the trailer. He liked the artist's style. Connie crawled under a card table to retrieve a coin and he heard the man say, "I want to buy that picture," Mary Ethel thought something had happened to Connie, because he stayed under the table so long. The thrill of making a sale was quite a shock.

The man from Wisconsin paid $35 for a painting entitled "Fence Mender." The couple celebrated. Then they sold another one for $30.

The long drought had ended.

CATHEDRAL IN THE SKY. *Oil on prepared board. 48x48 inches. From the collection of Mr. & Mrs. Jack Rosenthal, Casper, Wyoming*

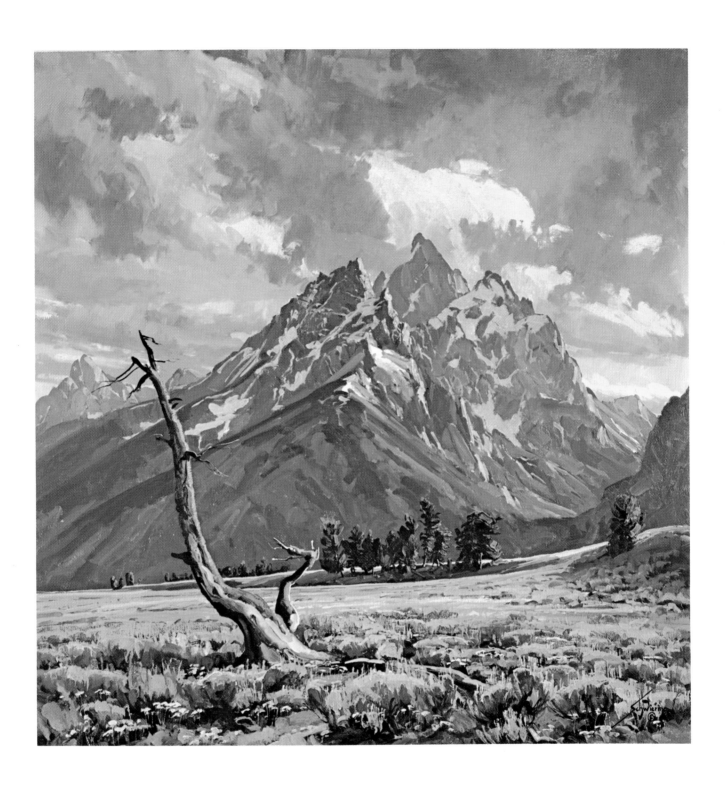

TOUCH OF TIME. *Oil on prepared board. 25x30 inches. From the collection of Mr. R. R. Bostwick, Casper, Wyoming*

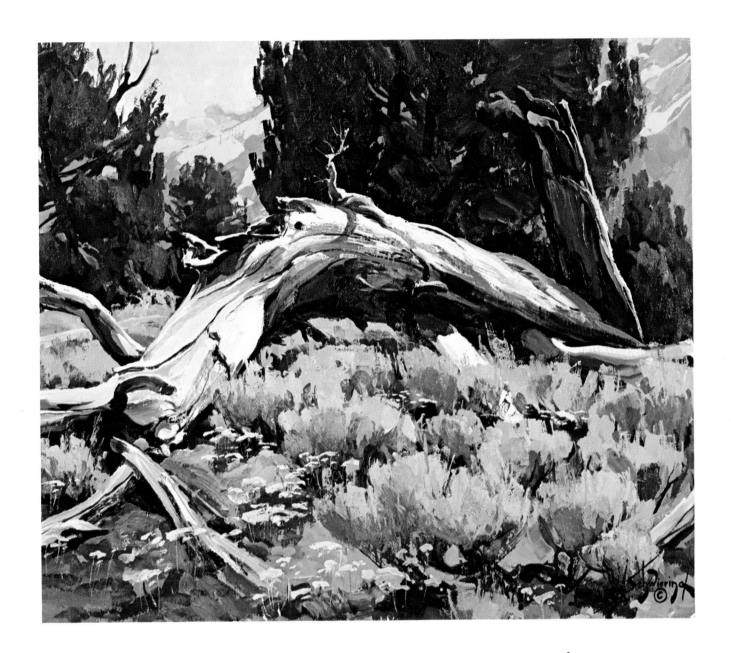

WINTER'S GRIP. *Oil on prepared board. 24x36 inches. From the collection of Mr. & Mrs. Richard Roskam, Moose, Wyoming*

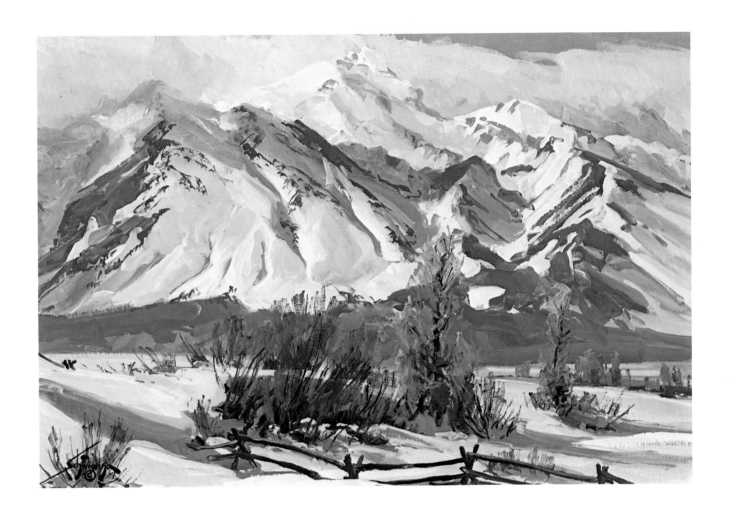

SINGLIN' OUT. *Oil on prepared board. 30x40 inches. From the collection of the Wyoming National Bank, Casper, Wyoming*

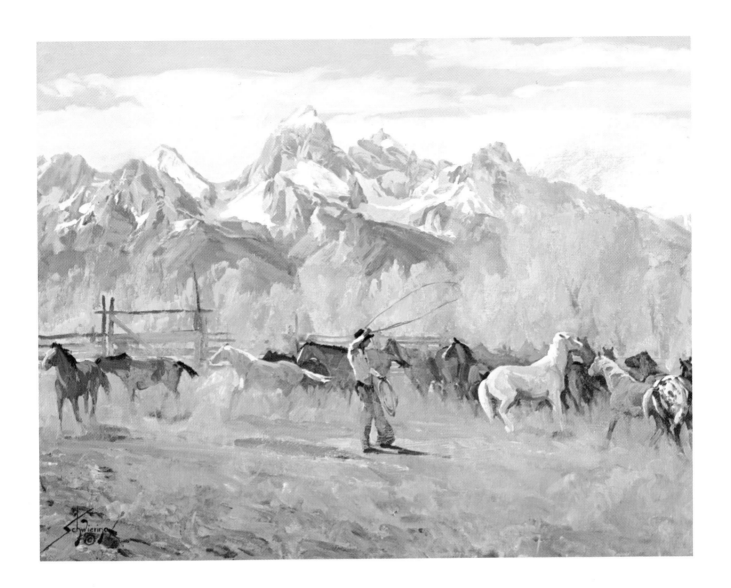

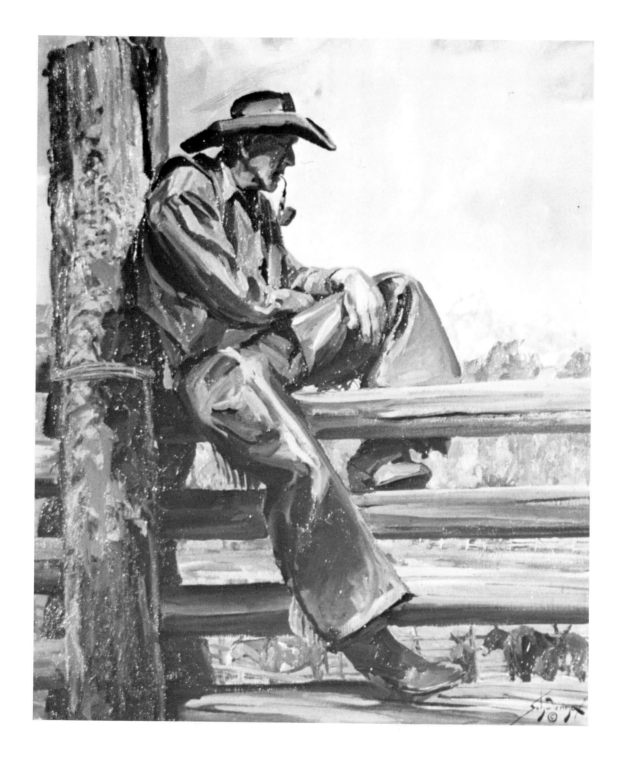

"Jack Davis" 30"x36" oil on prepared board.

CHAPTER FOUR

THE STRUGGLE BEGINS

Winter in Arizona was out of the picture. Connie decided that when he saw the first fall colors cover the Teton landscape. Cliff Hansen took him around the Teton Valley, where he worked with the cowboys. Dynamic and colorful scenery was everywhere, and he couldn't paint it fast enough. Joy burst from his brushes and blossomed on his canvases.

Earlier, the Jackson school superintendent came around and offered Mary Ethel a job teaching second grade. Then Connie readied the trailer for the harsh winter ahead.

He established a schedule for painting outdoors three days a week regardless of the weather. That practice has continued uninterrupted. At the same time, he read biographies of other artists and studied reproductions of their work, always concerned with the problem of reproducing the effects of light on a landscape.

They involved themselves in a myriad of community activities and Connie's service as a Lt. Col. in the army reserve unit took up the rest of his time.

In October, 1947, he wrote to Walter Biggs, asking him to support him in his bid for membership in the Salmagundi Club. He said in his letter, "I realize you know me only as a student fumbling around trying to get hold of the subject, so I have taken the liberty of sending you some reproductions of the things I have done since my release from the army. They represent some of my best efforts to date. Maybe after spending a lifetime at it I will begin to get hold of it and produce

43

RIDIN' DRAG. *Oil on prepared board. 30x40 inches. Whitney Gallery of Western Art, Cody, Wyoming*

pictures which tell of the strength, beauty and poetry of this country."

Biggs responded, "Have thought of you very often and it will be a pleasure to second you for the club. Give my best to Scott (J. Scott Williams, who had nominated Connie) when you see him. It is nice that you two can get in some sketching together . . . Liked your pictures and am returning them under separate cover."

Connie needed a gallery outside Jackson, so he turned to his friend Cyrus Boutwell. He took 25 or 30 pictures to Denver in November. At the same time, his first big spread appeared in the *Empire* section of the Denver *Post,* a full-page picture story with his painting of Ray Malody, "Ramrod," on the magazine's cover.

"Ramrod" brought $500 from the Denver National Bank, now the United Bank of Denver. The picture is kept in the vault and is displayed on "appropriate" occasions such as the annual stock show. "It's too bad," says Connie. "I didn't paint my pictures for them to be hidden in a vault."

"Ramrod" was the first of many character portraits Connie painted in an effort to portray the nature of down-to-earth ranch men, the backbone of the western ranching industry. His subject, Ray Malody, came from a family of horse breeders who supplied bucking strings for rodeos.

"I understand these men and I respect them," he says. "People have a tendency to think that Old Joe or Beaver Tooth Neal is an interesting character, but nobody pays enough attention to even take a photo of them. Then when they die everyone says, 'We should have done something about him — he was typical of the West.'"

Connie sent Charles Chapman a copy of his Denver publicity, and Chapman replied, "You certainly are coming along as I was sure you would. Your paintings are growing in color, composition and handling most decidedly. More power to you."

JY Ranch foreman Red Mathews was portrayed in many Schwiering paintings. He and his wife, Belle, ran the Rockefeller ranch which Louis H. Joy started in 1908, and they are lifelong friends of the Schwierings. Through Red, Connie learned more about horses and horsemanship. Red helped him in his quest for authenticity. One of the early paintings, called "Horse Talk," shows Red riding a new horse named Nugget. Red was teaching the horse to respond to a hackamore, which makes the animal sore under the chin and over the nose. He is shown meeting with two cowhands, who seem to be teasing him because he's late.

"Horse Talk" 30"x36" oil on prepared board

RAMROD. *Oil on prepared board. 30x36 inches. From the collection of the United Bank of Denver, Denver, Colorado*

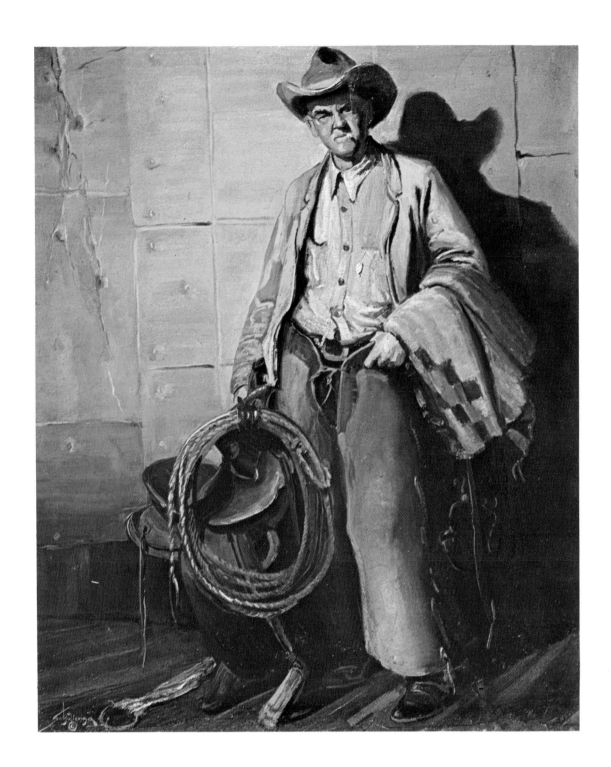

Connie traded "Horse Talk" to Frank Moore, a Jackson store owner, for some clothes. Moore kept the painting in his store, but moved it later into his home, tiring of turning down offers for the painting.

Soon after the Schwierings moved to Jackson, Connie drove out on Antelope Flats, about 15 miles north of town. The beauty of the spot took his breath away. Getting out of the jeep, he stood high on a grassy knoll. Before him lay the gently rolling flatland, and beyond that the massive Tetons, eight miles away but so close he could almost reach out and touch them.

"I've been on the land we ought to live on some day," he told Mary Ethel that night. "It's just perfect. It has a wonderful view of the mountains, and that's where we're going to live, if we can work it out."

Ten more years would pass before that prediction came true.

Wyoming Artist's 'Holiday'

O. Conrad Schwiering, 31, Jackson Hole, Wyo., artist, pictured with the sort of canvas he likes to do as "a holiday." It's a portrait study of Roy Malody, rancher-artist-railroader of Laramie, Wyo.

Meet O. Conrad Schwiering, Outstanding Empire Artist

A youthful artist who paints "because he loves the country" is putting the Jackson Hole, Wyo., sky and mountains and cattle range on canvas.

He is O. Conrad Schwiering, 31, who, with his wife, Mary Ethel, last year opened the "Paint Brush" studio at Jackson.

A native of Boulder, he gre~ in Wyoming, studie' York, ser~ then favorit and pe of the

PREFE!

His c the wes and blue. tumn scer

Althougl watercolor nounced s\ "more mall single work Perhaps ten thirteen year artist. period of stud

Besides stra Schwiering like "heritage studi people and the life. The focus of ings is a cowboy framed by plain also does an occa a western "charac

These last are In 1949, too, Mr. Schwiering could holiday." The other properly have been called the and butter." greatest and most consistent paint-

ARTISTS MUST EAT er of Mt. Moran that Wyoming

"I paint because I has ever seen. His 1949 paintings try that's really m showed him still preoccupied with painting and I've go brushes and brushwork. Last year, living. So I paint w nough, he had developed a fond- people will like." ness for autumn leaves. He paint-

business administration from the University of Wyoming. He studied during college week ends under the late Robert A. Graham of Denver and for a summer under Ber Phillips at Taos. In New York h worked under George B. Bridger the late anatomist, a~ Chapman a len~

ed them extremely well, and lovers of paintings of autumn leaves would have been delighted.

GREATLY IMPROVED THIS YEAR. Otherwise, however, the casual visitor to the exhibit would have away with an impression of

Grandeur of West Depicted In Schwiering Art Exhibit

By DORIS GRUENWALD.
Denver Post Staff Writer.

WORKS RICH IN CO

Schwiering Sells Art for $500

Sale of an oil portrait of a cow puncher, titled "Ramrod," to E. Dignan of Denver, a vice presiden of the United States National bank for $500, was disclosed Saturday by Cyrus Boutwell, art dealer, acting for O. Conrad (Connie) Schwiering, Jackson Hole, Wyo., artist. The painting was one of a number featured in the Sunday rotogravure section of The Den r Post last Aug. 15. Boutwell re- thirty

Schwiering Exhibit Continues All Month

By GORDON MARKWART.

excitement and roar of the west dramatically repeat es in oil on the canvases rad Schwiering, to con- hibit in the Cyrus Bout- ies, 1635 Broadway, mber.

've displayed p- ewer after th her here vino

NO PORTRAIT PAIN

The artist is proud character study call Guide. It, however, is The drawing leaves m sired, and that is criti Although Mr. Schwieri character study called that appeared on the Rocky Mountain Empi section last year, it from the two that portr is not yet Mr. Schwieri His landscapes, pleasing. He is not b artist, but is a much b this year than he was That can be seen by a l of this exhibit, for he ha some of last year's slightly reworked. While paintings are pleasing, th ence between those and t ings of 1950 is readily see Mr. Schwiering has had i of technical training, and enthusiasm for his work th assuredly make a fine pa him one day. He has a trul for the country we tendency

spectator into the life of th ing Storm," ponders the mys the impending fury. The charging effects of co the wes' fall receive thei atter the masterfully n Haze." Sch f the aspen-cir called "Lut ught out c arkling w

sunrise echoes th solemn i etons in

3d Schwiering Exhibit Considered Best Yet

By EDWIN P. HOYT III.
Editor, The Post Editorial Page.

The exhibition of paintings by O. Conrad Schwiering, 1635 Broadway, is well by far the best collection of work yet presented by that western

It is Mr. Schwiering's third ex- hibition at Boutwell's in as many years. In 1948, the artist showed a preoccupation with his brushes and brushwork. He revelled in his finely drawn foliage and particular mountains and his detail. He was wedded to Mt. Moran and others among the Grand Teton range of western Wyoming.

just before descending to a camp ground. Mr. Schwiering has brought life to a difficult subject in this.

His painting of a calf branding scene, while only a sketch for a larger painting, shows a ~ of action that Mr. s not exhibited often vious pictures. Ano kiln, is very pleasing

Schwiering Has Exhibit of Work In Denver Gallery

In Denver this week, an exhibi- tion of western art featuring the Jackson Hole country of Wyoming is being displayed at the Cyrus Boutwell galleries. The artist is O. Conrad (Connie) Schwiering, son of Dean and Mrs. O. C. Schwiering, 1408 Kearney, Laramie.

A graduate of the University of Wyoming, Schwiering has bee winning glowing laurels for h vigorous oil paintings of weste landscapes and character studi The Denver exhibit this w contains 30 of the young artist' paintings.

Says Gerard Curtis Delan ly-known painter, w

ver rs of a~

Reprinted from DENVER POST.

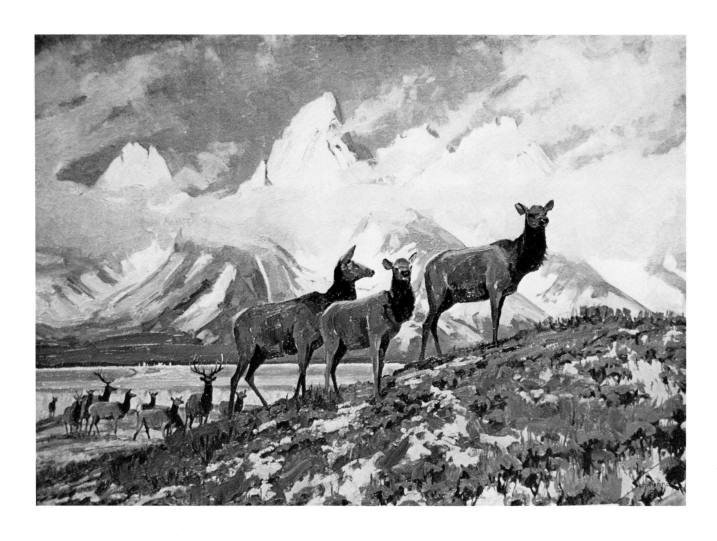

"Leading the Way" 30"x40" oil on prepared board

CHAPTER FIVE

THE MILESTONES

"Schwiering Art Show in Denver Hailed as Major Empire Event," read the headline in the *Denver Post* for November 28, 1949. Gerard Curtis Delano wrote in his review of Connie's show at the Boutwell Galleries, "At only 33 years of age, Connie Schwiering is off to a wonderful start as one of the country's best artists. Few there are so fortunate as to have traveled so far, so fast, and so well as he. With his fine training, his high enthusiasm, his great energy and ability, and with his open-minded and constant search for the truth, Connie Schwiering should travel far along the trail of greatness."

Gene Lindberg of the *Denver Post* wrote a story about Connie and Paul Gregg, who died in the summer of 1949. Lindberg told how Connie varnished Gregg's palette and presented it to Mrs. Gregg, a typically warm Schwiering gesture.

Others appreciated Schwiering's talents as well. *Rocky Mountain News* columnist Pasquale Marranzino wrote, "Ran into O. Conrad Schwiering the other day while browsing through the Boutwell Art Galleries. Connie is making giant strides in capturing the title of the greatest painter of the Rockies.

"A Jackson Hole, Wyo., native (sic) he has dedicated his life to a realistic re-creation in oils of the beautiful scenes in the Grand Tetons and other Wyoming and Colorado ranges."

Many friends helped Connie in his search for authenticity. Cliff Hansen, who later became Wyoming's Governor, then Senator, was one. From him Connie gained on-the-ground knowledge of a rancher's

problems and daily concerns. Often when they rode, Connie stopped to exclaim, "Look at the wonderful tone against the rock," or "See the reflection on the water."

One day, when the two of them were riding, Cliff said, "You know, Connie, I've ridden this country all my life, and I've never really seen it until riding with you."

Most of the Jackson valley was available to Connie for his outdoor research. When he closes his eyes and describes the sights and sounds he's experienced, he's recalling a love affair with the mountains.

He claims the bugle of the elk still raises the hair on the back of his neck. The moose "threshes around as he goes through the brush because he's big and tough, and he gives a lot of grunts. You want to stay shy of him during mating season because he's a vicious character then."

"In the late fall," he says, "the flying of the geese and the honking after they've gotten themselves organized is a picture you never forget. Then in the winter, when the ducks move, there's a whistle in the air as they go by, like something cutting through the air real fast and hard.

"When cattle are on the move," he continues, "first it's bedlam because every cow is looking for her calf. After they get mothered up, there's an occasional mournful call by a mother cow who hasn't found her calf."

As a boy Connie walked in the forest in the fall. The leaves were down and he kicked them and heard them rustle and felt them crinkle beneath his feet. Connie claims each season in the Jackson valley has its own characteristic sounds and smells, as unique as the scent of a stream flowing under some willows or cottonwoods. "A man is lucky," he claims, "if he's out on the prairie on a hot summer day when the rain comes up. To your nostrils, the rain over the sage is like champagne."

There's another characteristic sensation in the spring, when everything is fresh and cool. Later in the summer you can experience that same sensation by climbing the mountains. "The higher you get," he says, "the more it feels like spring. There you see the same flowers you saw in the spring down on the valley floor."

To most people the coyote's call is a mournful sound, "but it certainly isn't to those of us who have tuned in on it," he says. "When the coyote talks, you have nothing to worry about, because everything is in order."

Connie says the wind through the trees is music to his ears. "Aspen have a rustly feeling," he says, "that's why they're called quaking aspen, because the leaves are formed so they quake back and forth in

54

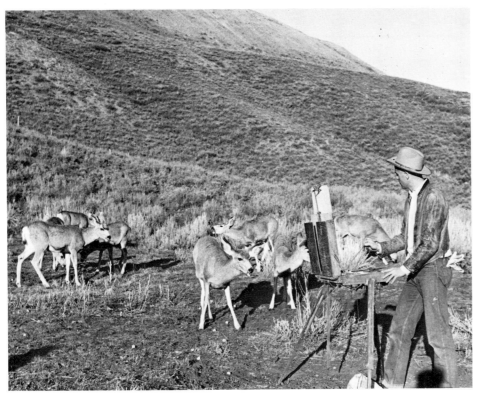

Schwiering spends hours outside in the Jackson Valley doing animal research. Sample sketches of his work.

the wind. Aspen have more of a whispering sound than the cottonwood trees. The sigh of the wind through the pine tells you what's going to happen. If there's a storm coming, you can hear it first in the trees."

He describes the sound of the Nighthawks over the prairie as they dive for bugs in the late afternoon, "When they get up high and come whee-eeee-eeeering down at you, you never forget the sound. They're feeding, but they're playing, too."

Connie claims the late afternoon is when things start to happen with the mountains, "and they begin to get the edge lights that help you build form. The skies warm up so there's a harmony of color you don't enjoy during the middle of the day. So sometimes I just roll out underneath the tarp where I've been working, like the animals, and just go to sleep. It's a good time for sleep — during the middle of the day."

In 1950 he returned to the Boutwell Galleries for his third consecutive exhibition, called by Palmer Hoyt "Best Yet." His successful shows proved catalytic to him, and he returned each time to Jackson with a great reservoir of enthusiasm. The search for authenticity continued.

When he painted a branding scene, he first worked with the cowboys, smelling the burning hair and fighting to keep his head out of the smoke while he hung onto the kicking calf. Painting at Reed and Helen Turner's Turpin Meadow Ranch, and at John and Louise Turner's Triangle X Ranch, he asked many questions. Much of what he learned about horses and their habits came from Red Mathews and a ranger on the Teton Forest staff, Charles Dibble. Many others helped Connie at this stage, including Slim Bassett, the subject of his painting "Slim the Guide." Bassett spent hours with Connie teaching him the proper hitches and how to pack elk and moose.

Al Murray, one of America's foremost portrait artists, was commissioned to paint portraits of the Rockefeller children at the JY Ranch one summer. He saw some of Connie's paintings displayed at the Wort Hotel, and told Red Mathews about his interest in Connie's work. After Red introduced them, they spent many days painting together. One evening after a day in the wilds Murray spoke bluntly to Connie.

"I'm going to give you some of the most valuable advice you will ever get," he said. "Get rid of those frames. They're killing your pictures."

Connie had built his own frames when they first moved to Jackson, but gradually gave up on that. He bought frames during their trips to Denver. In fact, he protested, "We've got all our money in these frames."

"If you have to," Murray said, "borrow some money and put good frames on your pictures. It will be worth the investment."

Soon after their conversation Connie began investing in natural wood frames made by the country's finest craftsmen. Now he's a firm believer that a frame is as important to the mood of the picture as the work itself.

When Murray returned to New York City and the Grand Central Art Galleries, he told them about the artist he had "discovered" out in Jackson Hole, Wyoming. The Galleries' director, Erwin S. Barrie, asked Connie if he was interested in sending some paintings for their consideration. Connie picked his best pictures to send, and was returned a letter of acceptance and a contract to sign.

Grand Central Galleries celebrated 30 successful years of operation when Connie became a contributing member. The Galleries were built originally in the loft of Grand Central Station, when founder Walter L. Clark signed a ten-year lease in his own name for the entire sixth floor of the terminal building. He hired a manager for the department of paintings and another for the department of sculpture. Sales in the gallery approached the $10 million mark.

Nobody owns stock in the galleries and no one profits from it. The lay membership fee is $350 a year, for which the lay member receives a work of art annually. Membership is limited to 100, and there's a long waiting list. Half of the proceeds acquired from lay memberships is sent to the artists who participate in the annual November drawing, after they fulfill their obligation to the galleries by contributing a work of art each year for three years.

Later that year, Connie was elected a member of the Salmagundi Club. Chapman had taken him to dinner at the club when he was a student, "and he helped me meet men whose work I admired. I saw that they were human beings and had fun like everybody else. When they had shows, I took them in with Mr. Chapman, another Valhalla for me."

Earlier in 1952, Connie's painting, "After the Storm," appeared on the cover of *Empire* in conjunction with a show at the newly named Marco Polo Galleries in Denver, formerly the Boutwell. Later in the year he returned for another successful show under the guidance of Arthur Porter.

The important milestones were beginning to pass. Election to the Salmagundi and Grand Central Galleries and reaction on a regional scale led Connie to believe that his hard work was starting to pay off.

During a trip to New York City to talk with Erwin Barrie at Grand

Central, Connie sought out Carl Rungius, dean of America's big game painters, and the man responsible for the Moose Group. He met Rungius when he worked in the American Museum of Natural History.

After Connie talked at length about his successes, modestly told, but by his own admission braced with cockiness, the wiry old German settled back in his chair.

"When you do two or three thousand," he said, "*then* you begin."

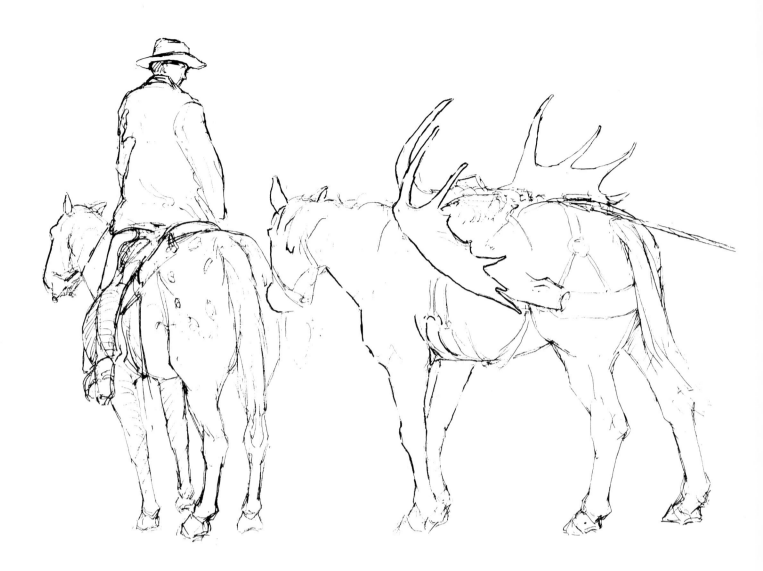

Preliminary sketch for "Bringing Home the Bacon."

"Bringin' Home the Bacon" 30"x36" oil on prepared board

"Cuttin' Through" 30"x36" oil on prepared board

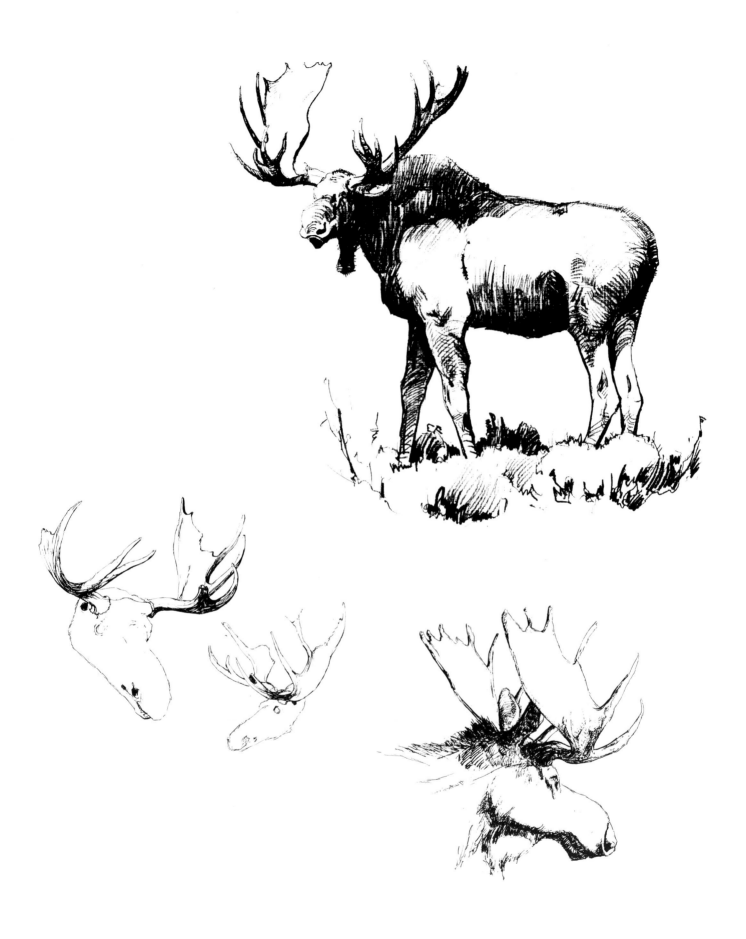

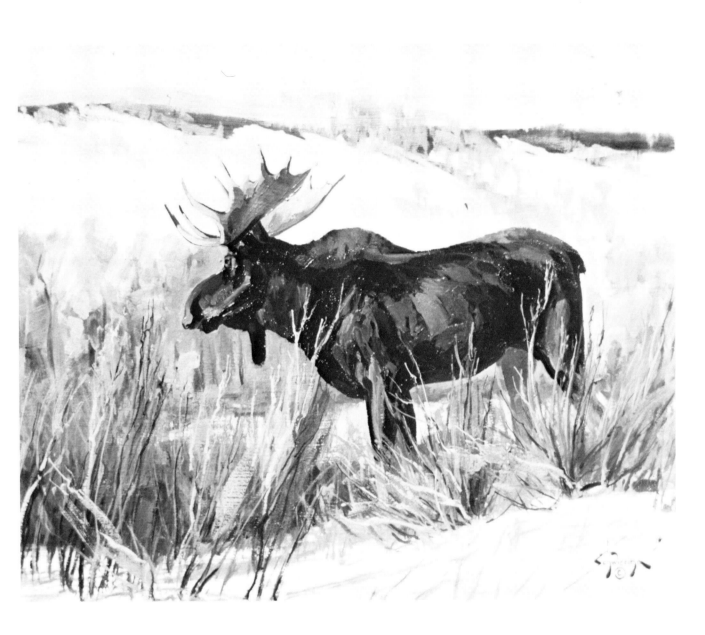

"Shiras Moose" 25"x30" oil on prepared board

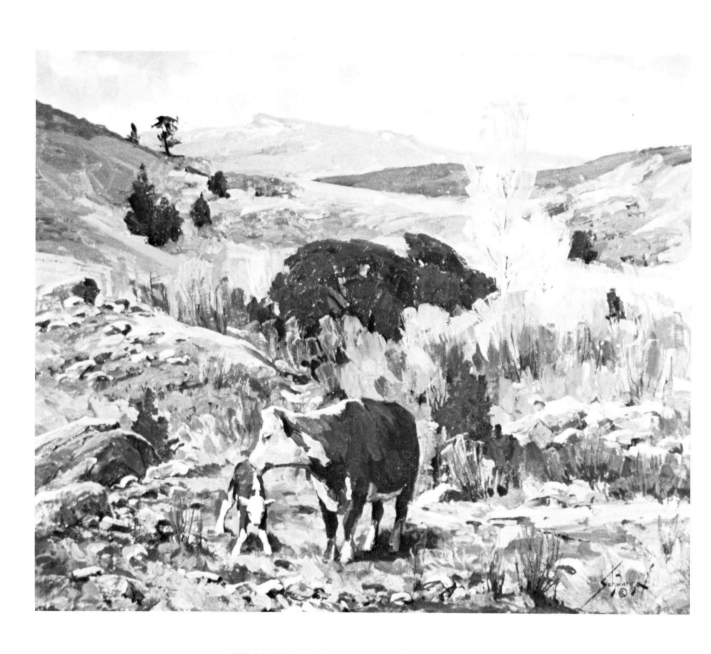

"Slickin' 'Im Up" 30"x36" oil on prepared board

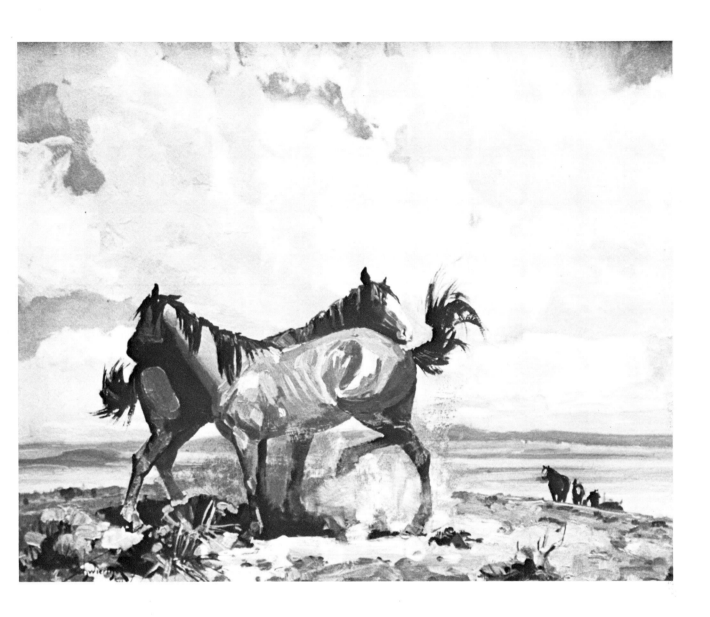

"Old Stomping Ground" 16"x20" oil on prepared board

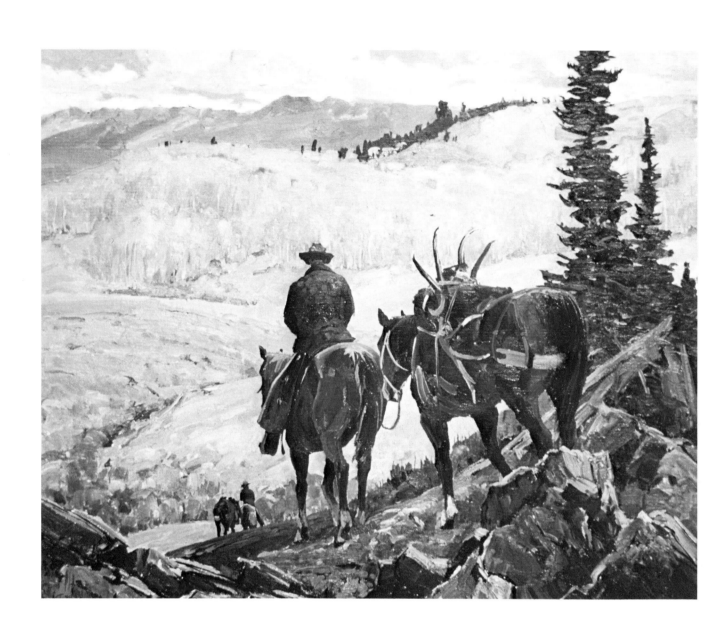

"The Pay Off" 30"x36" oil on prepared board

CHAPTER SIX

THE ARTIST'S DREAM HOUSE

"That artist is plumb crazy," said residents of the Jackson valley in 1951. With borrowed money, Connie Schwiering bought five acres on the old Carpenter homestead and set off a round of skeptical comments. "He buys land in an area where all that's there is sagebrush. He wants to build a home out there, but there's no road. And where's he going to get his water?"

Connie was way ahead of his critics. After consulting geologist Dave Love, he stopped worrying about water and started worrying about money to finance construction of his dream home. Because he wanted a studio in his home, he couldn't qualify for V.A. or F.H.A. loans. After trips to Cheyenne and Casper, where they tried to borrow $10,000 and were turned down, they thought that was the end of it. One of their Jackson friends thought otherwise and loaned them the money to get started.

Once he knew they had the money, Connie studied the land to make sure his house would afford the best view of the mountains and provide his studio with good northern light. Then he had to find someone to express his concept in architectural terms. At the time, Paul Wise's company was working for the Morrison-Knutson Construction Company, which built the Rockefeller Lodge at Moran. The first concrete step was taken by Nat Adams, an architect on Wise's staff, who made a working set of plans for the house.

Connie and his friends put in the foundation the first year. The following year they put up the cinder block walls. Then came the

concrete slab between floors, followed by the logs and roof. In the fall of 1958, close to election day, Connie got a call from Red Mathews.

"If we're going to move you out there we'd better start moving," warned Red, "'cause we're liable to get snowed in and won't be able to get the truck up into your yard."

They emptied their trailer furnishings into a stock truck and two station wagons and moved into the partially completed home on Antelope Flats. Behind them were 11 years in a cramped trailer. Ahead of them — a lot of work.

Connie picked the drillsite for their well from information supplied by Dave Love. As he promised, they hit water early at 28 feet and from there pumping water was no problem.

When the snow came, a surplus army weasel got them to the highway, where they left their car. The weasel became their life-line between home and town. They didn't mind the isolation. In fact, they welcomed it.

After spending a few isolated winters in their new home, Connie told Charles Chapman, "We think the most wonderful thing about the place is the never-ending mood of nature that passes on the Tetons just outside our living room windows. I haven't the words to describe it. I try to paint it and find that I am far short of the inspiration I experience. Still it is a wonderful challenge. I hope and pray that eventually I will really get hold of it. I suppose every artist feels this way.

"I am enjoying my studio," the letter continued. "Truly it is a wonderful place to work. I have planned everything so that it is handy and roomy. These winter months, free from interruption, give me lots of time to work and think. Our summers are busy, thank God, and I enjoy the association with the artists from outside. I am thankful for some time to collect my thoughts when winter comes.

"Along with the painting I do in the winter, I give one day a week to work on the house. We have been gradually finishing the inside as we go along. I still have two wall-to-wall type closets to go yet this winter, one in our bedroom and a linen closet in the hall.

"Mary is busy with the house," he continued. "I hope she doesn't wear herself out. It's a big place and she tries to keep it spotless.

"Thank you, Uncle Charlie, for all you have done for me. Each day I recall some of the information you so generously dumped over my head. Mary and I often recall the warm-hearted hospitality of two wonderful people. We were a couple of lost kids when you took us under your wings."

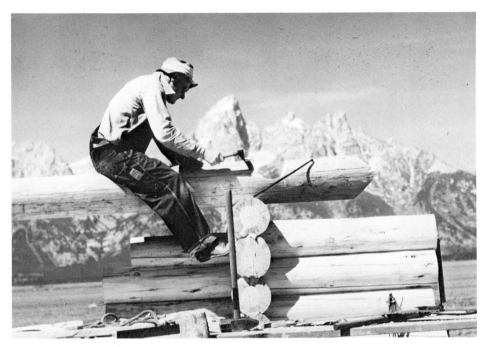

Claus was a fine craftsman who stood for no half-way measures.

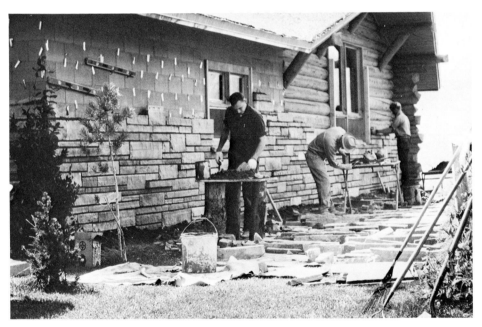

"They did all the stone work in about eight days . . ."

When they first came to the valley, Connie found some Swedes working on the Brinkerhoff cabin on Jackson Lake. After watching the craftsmen work their logs, he swore to have the same kind of log work done when he built his house.

When the last of the good house logs was cut from Black Rock, Connie bought a bunch of them and stored them on his property. A year later, his thoughts turned again to the Swedes who had hewn the Brinkerhoff cabin. One of them was still around, the indefatigable Claus Wester, who was about 75 years old. Connie found him in Dubois, 60 miles to the east in the heart of Wyoming's timber country. The old man nixed the idea.

"I don't build any more," Claus said. "I'm too old. I don't work on logs any more. I'm retired." Connie pleaded with him to at least look at the project, and he yielded.

A few days later, he returned from painting in the field and went to the little shack out back to get his tools. On the door of the shack was a beautifully inscribed sign that said, "Claus was here," along with the date. He took off for Dubois.

"I don't build," said Claus. "It's too hard to build. You've got special things that you want to build." Connie pleaded with the Swede again.

"I know you can do it," he told Claus.

"Yes," retorted the Swede, "but you got to hang three logs from the second floor before you start building. It's too hard. I don't build." Connie turned on his best salesmanship and Claus finally relented.

A few days later, Claus and a huge man named John Hancock showed up at the Schwiering homesite. The two men worked long, hard and with amazing dexterity. Before the first snowfall of the year, their job was complete.

The final touch was the Lyons Sandstone. Each time Connie made a business trip to Denver, he hauled a two-ton lot of sandstone from the quarry near Lyons, Colorado. The pile grew so slowly he gave up hauling it himself and contracted with a local trucker. Eventually there were 65 or 70 tons of stone piled in their back yard. There it awaited the stonemason's touch.

The late Max Fisher, president of the First National Bank of Laramie, had contracted with a man named Soderberg for the stone work on the bank's new building. He and his architect, Marvin Knedler, flew to Jackson in 1964 to pick some of Connie's paintings for the new bank, and Max noticed the pile of sandstone in Connie's back yard. When he got back to Laramie he told Soderberg, who called Connie.

70

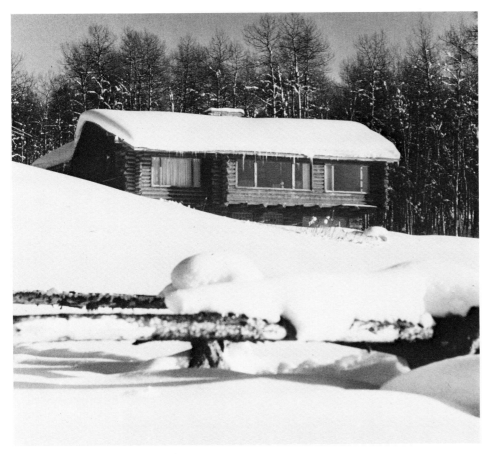

At last, the finished dream house . . .

Connie sent the Swede his house plans and didn't hear anything further until the middle of August, 1964, two months after the bank's grand opening.

"I'm ready to do your stone work," said Soderberg.

"What do you mean?" asked Connie.

"I'll do your stone work for $3,000 if you let me come up right away," he said. "I've got men here on my tail and I haven't got a job to put them on." Connie protested.

"This is right in the middle of my busiest season," he told the Swede. "Can't you put it off until after September at least?"

"No," said the stonemason, "I'm out of work. If you'll let me come up and do it, we'll do it fast and we'll do it right." Connie gave him the go-ahead.

Soderberg brought six stonemasons and two helpers and they flew at the house like a "bunch of elves." Every door was blocked by scaffolding, but that didn't seem to bother any of Connie's customers. Connie told Soderberg he wanted the house to "look like it was in the country, but built by craftsmen." Rather than let them fit and trim every corner as they would a city building, he insisted they overhang the rock in-and-out for a rustic country effect. They protested.

"Well, I'm the one that's paying the bill," he told them. "If I'm not happy, it's my responsibility, not yours." They did as they were told. About a third of the way along, they began to see what Connie was driving at, and they entered into their work with a new spirit and ingenuity. They completed the stone work on the house and garage in eight days, with no time off.

They were finished. Their dream house at last stood complete, evidence of the artist's vision, his independence and his fierce determination. This was more than just a home. It was a work of art. From the rough, unsmoothed sandstone, to the unusual bleaching oil finish, Schwiering's house was as unique, as unpretentious, and as attuned to nature as the artist himself. It was his architectural vision come true.

Thirteen years earlier they sat on a grassy knoll with their picnic lunch and talked of this day. Behind were six years of living in the partially completed structure, 11 years spent in their trailer and the years before that waiting to get started. For the rest of their lives, as they watched the endless moods from their picture windows, they would remember the waiting, and hoping, and working.

For both of them, their home would be the most meaningful milestone of all.

Connie and Mary Ethel sit and watch the endless changing moods from their living room window. (Photo by David Laustsen.)

AUTUMN BANNERS. *Oil on prepared board. 30x36 inches. From the collection of Dr. & Mrs. Frank Selecman, Dallas, Texas*

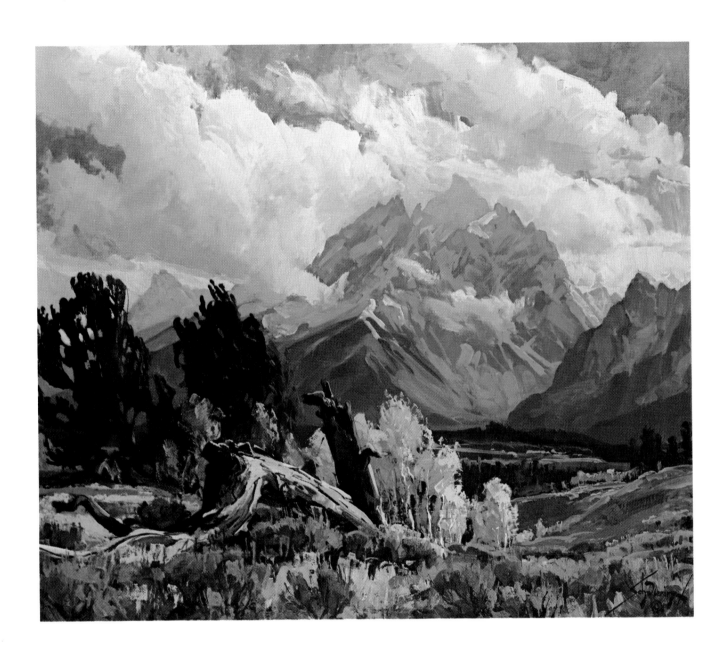

SANDY MORLEY. *Oil on prepared board. 20x24 inches. From the collection of Mr. & Mrs. Alex K. Morley, Moose, Wyoming*

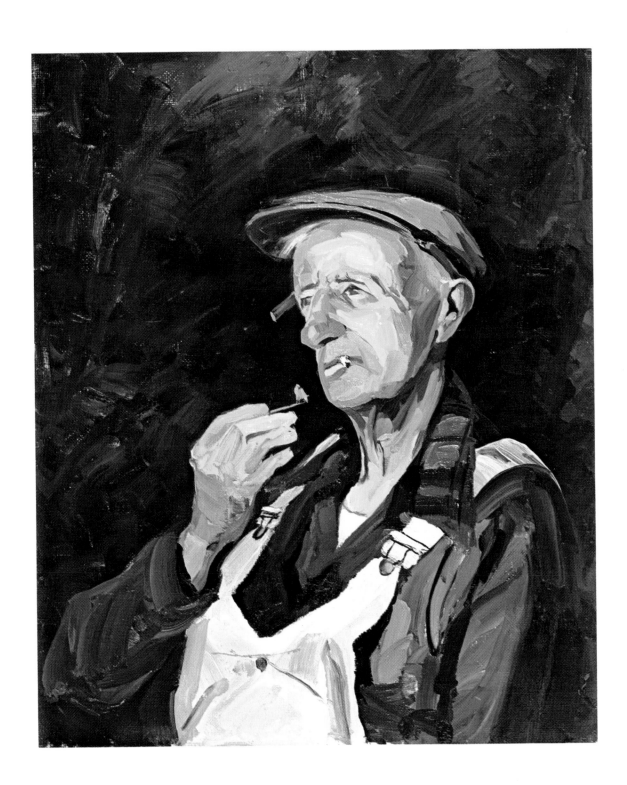

GHOSTS OF THE MORNING. *Oil on prepared board. 30x36 inches. From the collection of Mrs. Jack E. Haynes, Bozeman, Montana*

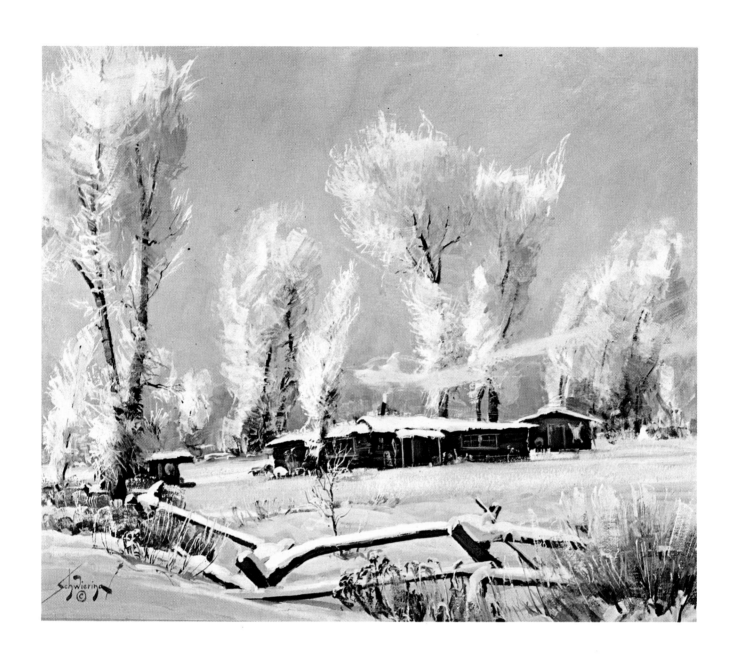

HIGH COUNTRY GARDEN. *Oil on prepared board. 20x30 inches. From the collection of Mr. & Mrs. William Bagley, Cheyenne, Wyoming*

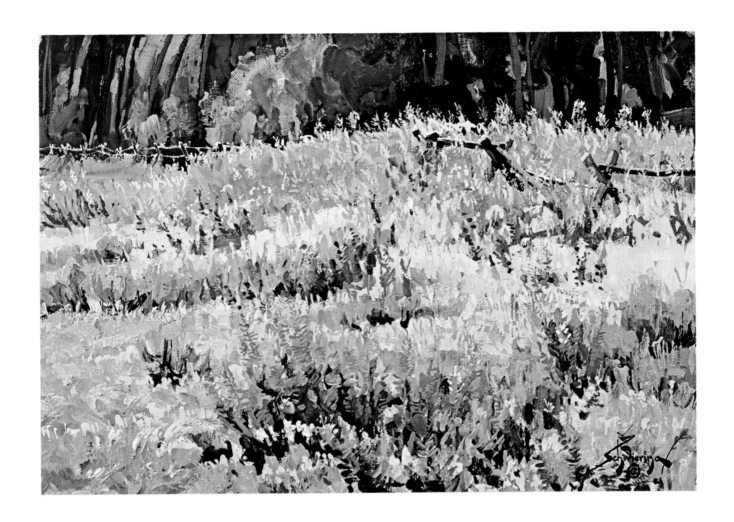

"The thing we do is to aspire to do something significant. If a man doesn't realize his insignificance, he never will accomplish anything. His achievements are so very minor on this great earth. Everything we do *has* to be done with the knowledge that it's probably not going to be any great splash in the overspan of time."

— Conrad Schwiering

BED ROCK PHILOSOPHY

In the following section the author pauses for an interlude with Conrad Schwiering. This section provides additional insight into the artist's philosophy and technique. The biographical story continues in chapter seven.

Note — what follows serves to explain Conrad Schwiering's philosophy on a great variety of subjects:

CS: It isn't enough for an artist to create a blob of color that's interesting. Or an interesting area of spaces. Or rhythm on canvas and call it a picture. That *isn't* a picture; it is interesting design, color, or it is *what* it is. To become an artist is a matter that involves intensive training and study and it does not come any other way. No one is born to be an artist. They may have been born with this burning flame, this desire that drove them to make the sacrifice and acquire the knowledge, rather than have it occur out of thin air.

I don't want to be an old mossback and say all modern art is terrible, because that's not the way I feel — I *am* a modern artist. I'm an impressionist. I produce things that are very loosely put together with a desire to create an impression of the things I'm talking about. I think this is modern; it isn't non-objective. I am an *objective* painter. I hope that when I get through saying something about a cloud or about a tree or a horse or moose, or stream, that the feeling of the essence of my subject comes across to the viewer. That's really the basic philosophy of an impressionist. This doesn't mean there isn't a lot of good in abstract painting . . . that there isn't a lot of good in cubism, because all of these

things are included in art. Funny thing is, I just don't like to have somebody tell me I have to do it one way or another. I fell into what I do just by trial and error and intensive mental anguish. There's no other way to put it. I just worked so hard to learn to do the things that I feel and see by applying myself; I don't know any other way to do it. You have to *think*, because if you don't use your mind, with all the inspirations that you may have — you're not going to say anything. You have to learn to coordinate the impressions that come through your mind and through your skills express it.

Early in my training I learned that the most important ingredient is the conviction within the artist that he has something significant to say and that he is the one to say it.

I work at a high emotional pitch attuned to the fleeting moods of nature. Nothing can be allowed to interfere with the process of translation of the impression. Isolation from all extraneous harassment is essential to concentration.

BW: George Innes talked about "the subjective mysteries of nature."

CS: That's what I mean when I talk about "essence." Everything is beautiful — if you let yourself look, if you let yourself study the landscape. If a painting doesn't relate to something that is translatable, it falls short in that degree. That doesn't mean it isn't good color or good design. No matter how you color it, or how you talk about it, the artist's intent when he sees something he thinks is worthwhile expressing on a canvas — is to express his feelings so that others can enjoy it. That you are only doing it to satisfy your inner self is a lot of hooey. We do it for ourselves — but we hope others enjoy it.

BW: How do you work when you're out in nature?

CS: You're supposed to be prepared. Have a board that is toned with a general value, rather than starting from scratch. Don't have to fight to get a color that way. You see, when you paint what you are doing is relating one color or one color tone to another color tone to create an illusion. This is what art is, fundamentally; so, if you have a white board, you are working against it, so you can't really create anything until you cover that white board so that your color values can be used against each other. This is what makes a painting. This is what creates the illusion of depth; this is what makes a tree look like a tree and water look like water. When you do a sketch you do it on grey paper or blue paper, to have a tone to work with. I carry maybe 30 or 40 boards out with me, so that I have all different kinds of tones that are similar to the tones that come out on the mountains — and then I pick the board that is nearest in tone to the mountain at the time I'm going to do it. This isn't something that hit me all at once. This approach came over all the

years I've been working in here, trying to learn how to get a mood quickly. And I can do it fast; I can get a mood on a fairly good sized piece of canvas in a matter of 30 to 40 minutes. I get enough of the mood started, so that, if I trap the mood, I can make the picture fit the mood. After all, this is the reason for doing it — the mood is why I paint. It isn't simply because I want to paint a picture of the mountains. I want to paint a picture of the excitement that occurs when the elements play against the mountains. I feel the same kind of mood on a sea coast. I'm sure anyone who has followed the sea feels the power and the interest of the sea as it strikes the shore; the colors, all affected by the atmosphere at that particular time, and the fact that the elements are affecting the sea so that it strikes the shore a certain way. I think the sea deserves the same kind of study that I've put in trying to do mountain landscapes and horses and trees, animals, and the things that are here in this great valley. It's a matter of getting in and doing a little of the spade work that gives you a little progress with each thing. It's fundamental — like trying to walk from here to the other side of the room when you were a baby. You first learned to go a little way; eventually you go one step farther and this is the way you grow as an artist — you have to think and recognize it as you do something that is successful. I jump in and do some of the worst things because I'm experimenting. But, you never grow if you keep doing it the same way you did it the last time. Your mind will never grow and your work will never grow. What I try to do is hurdle myself in a direction where something is happening and get in there and swim. This presupposes an awful lot of this background stuff that we're talking about — that is, using a toned board, analyzing the area, familiarization with the forms, and composition planning, to give you a head start.

BW: Duran predicted that American landscapists would evolve a "high and independent" style. Do you feel perhaps that this is what you have done here?

CS: I agree my style is an independent style because I won't let anybody influence me. This is a pretty big statement for a guy to make who talks about studying the old masters, who talks about the work that you have to do to study fundamentals and learn techniques and all this, and who continually reads about the artists he admires in history because of their accomplishments, and keeps studying their pictures. But, my approach is very singular in that it has not been influenced heavily by other artists *after* I started on my own. I think this is the key. I certainly wouldn't say that I haven't associated with other artists and that it doesn't help me—because it does. But, very often, what happens in various schools (and isms), one strong and dominating individual within the group will influence quite a few because they sit together, they criticize each other's pictures and they hob-nob and think —

"Well, what will old Joe think of this approach?" and "What will such-and-such think about that approach?" That's not the way I'm trying to solve my problem. I'm not trying to solve it by considering how someone else will like it. I don't ask myself — "How will it affect someone that I admire? Will he approve of the way I've applied this thing?" My problem is simply to try and solve it. That's different than many, because I came out here to paint what I think is the finest landscape in America. I cut away from all the ties and made no pilgrimages to be with the artists of my age. My attempt was to try to solve it in the best way I could — my own way. I realize that I stumbled a lot in trying to do it, maybe produced many things that don't amount to much as pictures, but with every one of them I learned something. I don't know whether it's a new school. I do say it is important to be on your own and not be dependent on someone else's ideas and thinking. My way of doing things has evolved in the 25 years we've been up here. It was really a slow evolution — because I was impatient. I get in over my head in every picture I start to paint. But, you've got to swim. I never start a painting that I don't feel will be great. I say to myself, I think this subject is inspiring and exciting. It has possibilities for a painting. Then I consider how I might express it on canvas, and I hope to God that I am up to it. Then I begin. I suppose it's sort of like a think session with a group of people, because some avenues that you're working on you don't think are going to lead anywhere — then, all of a sudden it fits with the other elements and it opens up into a real good solution to that particular problem. The important thing for an artist is to do things — and then to recognize. You see, if you can't recognize when you have made an interesting statement, or an interesting relationship of colors, or an interesting brush stroke — if you don't recognize it, you kill it, and if you kill it then you systematically ruin your picture, because your picture comes out as a mish-mash of nothing, because every interesting statement has been destroyed. So, the old saying that an artist needs somebody standing behind him with a club ready to hit him over the head when the picture is finished is true — but he's the one who's got to be doing the hitting; he's got to learn that overstatement, overindulgence is the sure way to nail a picture right down to the ground and kill it. And this thing that we're talking about has to happen all the time when an artist's working. He's got to be aware and he's got to look at it critically and see where he has it and where he doesn't have it. If he doesn't have it in his opinion — then he's either got to change it, correct it, or scrape it out and start again. You have to be that severe a critic. You must criticize yourself objectively — and this takes some doing, to sit back and look at what you've done and see where the holes are and then think, how am I going to overcome these obstacles that stand in my way, keeping me from saying the thing that I'm trying to say. Another thing; I work with moods, and I try to

Preliminary studies for oil painting, "Searching For Supper."

be ready so that, when the mood is on, I can paint — I don't have anything to worry about. I don't have to worry about getting paint out or brushes, or whether the wind is going to blow my canvas, I'm ready. Nothing but the thing that's happening is of interest to me, and my sole purpose is to translate the essence of what I see to my board, and hope that it will come through so that others can feel it. The time involved is maybe very short, and that means intense concentration. Sometimes, when I'm working against time to capture a fleeting mood — combinations of color, form, and brush strokes occur that aren't consciously governed. I work in close tune with what's going on. I don't know how to describe what happens in a better way. I feel sure that this must be similar to the way music is composed.

BW: It sounds as though you approach your subject by asking yourself, "What's going on here?"

CS: That's the thing that keeps me continually excited. When I go out to paint the country, the things that are happening are so interesting that it is awfully hard to go where I originally wanted to go to paint. There are a thousand things that are good that I see on the way. When I'm working on a subject, this is the hardest problem. If you can't select the mood that you're going to try to paint, if you can't sharpen your mind and your selective powers down to the point where you have a fixed impression of the thing that you are trying to do — you *follow* what's going on. If you follow moods, you get nothing but a picture that's a mish-mash, a little bit of everything. You get a painting that isn't satisfactory because it doesn't *say* anything, it doesn't convey one vital statement. That's what I try to get.

BW: You taught for seven or eight years here in the valley. Do you like teaching?

CS: I give students too much to do. I pile too much on them; I encourage them to do so much. I'm anxiously pushing them 'til God Almighty couldn't do it. This is the problem. It *has* to be learned. Gosh, I can remember when I was trying to learn it in New York City. There wasn't an evening after school that I wasn't so disillusioned and so disgusted with myself that I wanted to go home. I wanted to go back to Wyoming and forget the whole thing. I think an artist is continually confronted with discouragement, because he cannot accomplish the vision that he has. He cannot accomplish the real beauty or interest in the things that he feels. Because he's just an individual, he's got just so much skill and so much knowledge — and that's far short of the things that he can see and envision.

BW: Did you ever copy the paintings of artists you've admired?

90 CS: I discovered that trying to copy somebody else was thoroughly a

waste of time. The important thing is to try to think for yourself and to accomplish the thing in your own way. This is why I don't have much background on other people; I don't know much about my contemporaries. It doesn't mean that I don't know what Wyeth does or that I'm not aware of some of our fine painters, such as the late Frederick J. Waugh, who painted the sea. Someday, America will realize it had one of the greatest sea painters the world has ever known. He was a *fine* sea painter; painted the moods of the sea. He is one of the men who influenced me heavily in the way I paint.

BW: He was also, like you, a member of Grand Central Galleries, which seems to me pretty good company to be in. Do you have *fun* when you paint?

CS: It's hard to say I have *fun* painting, because it's something I have to do, to breathe, in order to live. It's just that deeply imbedded in me. I don't know what I would do if I couldn't paint, if I couldn't draw. I can't take a vacation for a week without having to go somewhere where I can draw or paint. No matter where I am, I'm just not happy unless I'm working. So, it's wrong for me to say that it is great pleasure, because it's a continuous struggle to accomplish the thing that I'm trying to do. This is work; it's not like playing a game of golf or going fishing, that kind of fun. If the fisherman is the kind who is completely crushed if he misses a strike, then that's the way I paint. I tell people that my work is my hobby, but it's more than that. I feel the things so keenly and I want to be able to express them. I keep telling you that we always fall short. I don't believe Michelangelo could stand back from his wonderful creations and honestly say, "That's perfect." Within him there must always have been the feeling that he could have done better. So, that's why I say it isn't always just pleasure. But there is great therapy, as you know — your mind is so involved that you're not aware of anything else around you.

BW: It sounds as though you work seven days a week.

CS: I paint every day that I can. Some days I have to go to Rotary, or do some maintenance work around the place — but my main concern is in trying to produce pictures; I'm working nearly every day, an eight-hour day or longer, sometimes a lot longer. When summer comes on and we have the long days with Daylight Savings Time, I get in about 8:30 or even 9:00 at night, after starting early in the morning. You don't go into the business of being an artist to get rich; that is, a real artist doesn't go into business to make sales. And, he isn't involved in the business to try to impress people. He's involved in something that he wants to do so badly that he can't be satisfied with himself or with life if he isn't doing it.

91

SEARCHING FOR SUPPER. *Oil on prepared board. 30x40 inches. From the collection of Mr. & Mrs. Thomas Wolkos, Elm Grove, Wisconsin*

BW: You seem to be in the enviable position of doing exactly what you want to do.

CS: To be somebody who really accomplishes something, you've got to dig in and aim at one bullseye and *hard* at that bullseye. You have to select things that are meaningful to you — and if they are meaningful to you, someone else will get the meaning, the real translation. When it finally bites you — the thing that you are really dedicated to — you can consider yourself lucky. And, money isn't a mark of accomplishment — it's the material mark — but money should not be the only consideration in judging the *quality* of art. Success isn't based on money alone; a man must be happy with himself and his accomplishments in his field. I've *never* tried to do what I do with sales in mind. I've tried very hard to become a painter of the moods of the country. I paint the prairies, sky, streams, mountains, people, horses, ranch life, the wildlife, and all the things that mean so much to me in this western country. My desire is just to do it in a fresh, honest, clear statement of the things that I feel, not thinking in terms like: "This is going to be worth $3,000 when I finish," or "This is something that is bound to sell." After it's done and we can sit back and evaluate and equate the things that I've said with the existing market, we are not going to price it under what I think I can get. How much you can get, in terms of sales, is not the way to judge your success, nor is the accolade of the museum acquisitions or winning in various shows. These are marks of the most successful artist, and they are pertinent factors. It's been my experience that people recognize something that has it. Throughout history, the great works of art have survived because of their universal appeal. I am sure this is as true with music and literature as it is with art. If it has the basic quality, they know it. Man is of such little significance in this world that I don't feel we have the right to think that we are going to accomplish great things. The thing we do is to aspire to do something significant. If a man doesn't realize his insignificance, he never will accomplish anything. His achievements are very minor on this great earth; everything you do *has* to be done with the knowledge that it's probably not going to be any great splash in the overspan of time.

BW: So there are times when you don't succeed in saying what you'd like to say.

CS: When I do a painting that ends up in the trash can, I don't feel that I've failed miserably, even though the picture is lousy. I've learned something *not* to do again. An artist needs the buoyancy of inspiration and the thrill of inspiration when he works. Now, if he's produced something that isn't exciting when he looks at it, if it doesn't give him the buoyancy and the urge he felt when he started on it — then he had better stop working on it; throw it away because it's going to be time

94

wasted in trying to salvage something that doesn't have it any more. I just quit. There are so many other things that I'm trying to say, that I'd better get on to another one and try to say it with that one the best I can. You have to recognize a failure when you have it. Life is like that. Pictures are a lot easier to start than finish. I suppose the less the artist concerns himself with trying to finish a picture, the better off he is, because he will allow much more of himself to occur in a picture, rather than trying to embellish it with all the knowledge he has. You have to ask yourself, "Have I said enough? Is it necessary for me to add more?" I can remember somewhere back in my training, somebody instilled in me the feeling that it's more important when you're in trouble with a picture to think what you can take out to improve the picture rather than considering what you can add. Chances are, you have too much in the painting to begin with.

BW: Does a camera play any part in your work?

CS: Absolutely, I use a camera; the only thing is, I don't let the slide make a slave out of me. The picture that you get, you must remember, is a mechanical thing. The camera sees with quite a few limitations that the artist doesn't have. The film is flat, and it rarely gets the subtle things in nature. The camera gets the big impression or the big color and sometimes it's not right. The subtle things that interest you and make you think — "That's worth taking a picture," is rarely evident in the finished photo. Film is made up of different chemicals. An artist today who doesn't know how to use a camera is limiting himself; it isn't going to hurt him, it's just a tool, just as a sketch box is a tool, It's no more than just one of the things that he can use to get the information together so that he can create the thing that he's going to do. I use slides to recall moods even though they don't do it very well. They will refresh my memory to start me thinking about something. I use it with animals for anatomy, to be sure that I'm right on the structure of the animal, or the animal's attitude. But, most of my work is done with the animal. I always get the horses to pose for me; or I get the rider and horse together when I'm ready to do the final work on a picture. I work from a live model because there's something that occurs in the picture that can't occur from a photo. I had a lady who runs the Old Town Gallery in San Diego try to get me to send something to their All-California show. I wrote her and said I didn't have anything of California, that most of my work was of this area and probably wouldn't fit with the show. She said, "Well, you paint mountains so well and horses and trees and whatnot, I'll send you some pictures of Mount Shasta. We need a powerful picture of Mount Shasta in the winter. I'll send you photos of that, and I know it will be just great in the show." It took me fifteen minutes one night to convince her, over the phone, that I didn't think that I could do a successful picture from a

SPELL OF THE HIGH COUNTRY, *Oil on prepared board. 36x48 inches. From the collection of Mrs. Conrad Schwiering, Jackson, Wyoming*

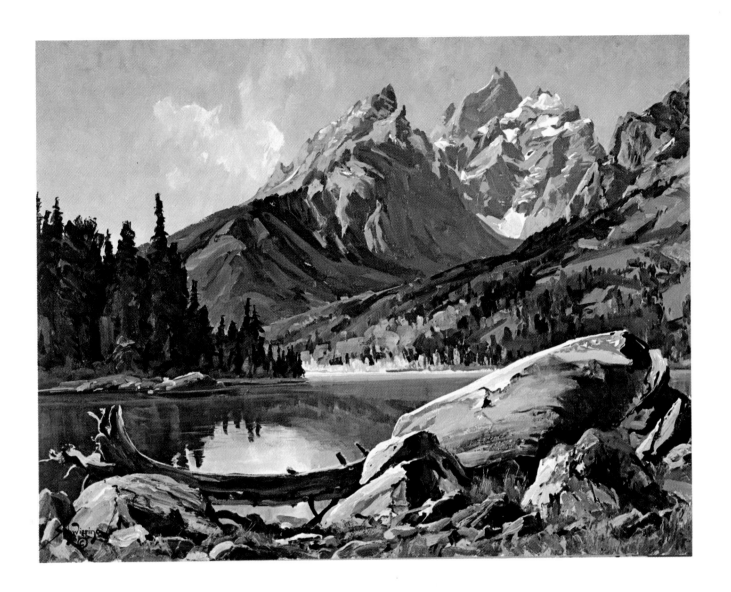

photo that she gave me, without having the research on the ground, working with Mount Shasta in the winter. That's just basically my philosophy — if you're going to do something, you have to digest it. It has to be a part of you, and it has to be you all the way. You have to think about it; you have to draw it enough so that you are very familiar with it. You must know the anatomy of the subject you're working with; the anatomy is part of your intimate knowledge. Then, you can paint something, making a statement about your subject and be free of the restraints of being too accurate, too mechanical, too much like a camera. Then you can be an artist; this is the important thing. So, when someone makes a statement like that, I realize they are not thinking as an artist thinks about producing a work of art; they're giving me their highest accolade. A very important part of art is not to overstate — but to understate. The knowledge and power that the artist possesses is very apparent, if he can understate it. It's the understated inference that leads the viewer into thinking, into translation. I tell people that, if they can't discover more about my pictures, perhaps I have failed, because this is what an impressionist tries to do; he tries to create an illusion that is endless. The viewer should be able to read into the picture many things that I don't even think about; their minds should work on the picture. If it is all stated, then the mystery is gone.

BW: As we drive around the valley, you use a lot of geologic terminology in describing the landscape; what part does the study of geology play in your work?

CS: A landscapist should know the formations of the country he's working in; he should pay attention to them; he should investigate. If he doesn't, he'll make terrible mistakes with his landscape statement. I don't mean that you have to do a photographic image of what the landscape is, but if you make something a bench — and it isn't a bench — it destroys the character of that landscape.

BW: What about botany?

CS: Botany was one of the subjects in which my father was very interested. Of course, you heard the story I tell about how he probably was one of the reasons I became so enamored with this country. His love and understanding of nature was passed on to me, even when I was a little fellow carrying a fishing pole behind him when we'd go fishing — and he'd take time wherever we were to explain the wonderful things around us. This, then, makes you more conscious of your surround- dings, more inquisitive. It seems most artists I know have a very inquisitive nature; they want to find out how things tick. They want to find out why it happened, how it happened, what makes it keep happening. Our search is continually an inquisitive search regardless of the subject. When I decided to become an artist, it was a matter of

wanting to say something about the beauty I saw around me in the country. I never once thought that I wouldn't be able to do it. In spite of all the evidence to the contrary, that told me you don't go and paint easel pictures and make a living out of it; you get involved in other things and do your painting on the side. I'm sure I was even confident when I was painting on the town square. This faith that comes with the desire to do it — or the burning flame — gives you so much confidence in yourself that you can accomplish whatever you make up your mind to. I didn't once, ever, any time have the idea that I wouldn't be able to do what I wanted to do. I didn't know *how* I was going to do it; it just never entered my mind that I might not be *able* to do it. I've had a lot of people talk to me about it since then, who say — "It sure must have taken a lot of determination to do what you've done." As I tell them, there's no way you can combat it, once it's a part of your makeup, part of your philosophy — there's no way you can turn back; at least I can't. I've studied a lot about the lives of a good many artists, and I think that most of these men were driven by that same kind of unexplainable urge.

BW: Are all artists temperamental?

CS: Certainly, I think it is necessary. The development of a sensitivity to all things is part of the normal growth of an artist. The place for temperament to show is in your work.

BW: Winslow Homer?

CS: He is my kind of artist, a man who was deeply interested in the things he was trying to express. He did them simply and directly and honestly from his experience and knowledge. Homer had made a living for years as an illustrator, with a strong, disciplined background in the fundamentals. When he started out to express the Maine coast, the people, sea, and rocks, he accomplished a very thorough statement of the subject matter that he was involved in. He was a fine watercolorist and a fine oil painter; I don't think that America realizes right now that he is one of the *great* painters.

BW: You are in your early fifties; what "stage" of development as an artist would you say you are in?

CS: Homer did most of his mature paintings when he was in his sixties. An artist reaches that stage because of work and the seasoning of his mind. Trying to do the things that I've been talking about, continual searching for the fundamentals and the elemental things in your picture, helps to bring this maturity. I'm sure that, as the artist grows older and his knowledge and experience mount up, his control becomes stronger and stronger. He can say in his pictures things that are more meaningful with much less paint and less verbiage. Therefore, the painting becomes elemental and fundamental — and, the nearer the

SLICK ROCK TRAVELER. *Oil on prepared board. 30x40 inches.
From the collection of Mr. Horace W. Adams, Paw Paw,
Michigan*

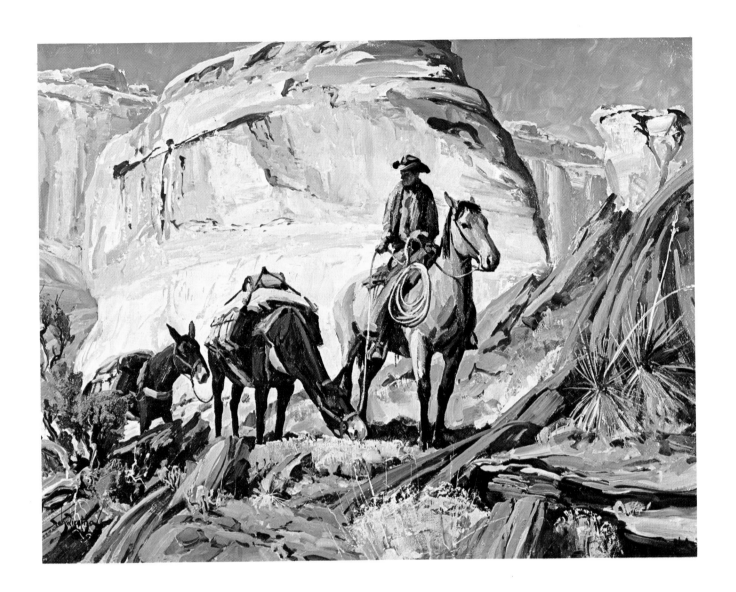

painting comes to this, the greater its chances of becoming a work of art.

BW: What part does the artist's personality play in all this?

CS: Art is nothing without the personality of the individual who creates it. This is one of the great things about art, because each of us is endowed by our creator with a personality that is ours and ours alone, an opinion that is ours alone. If the artist is worth anything, he should be creating something that is very highly personal to him; it shouldn't be what he feels someone else is going to admire. It *is* almost essential that someone else likes what an artist does well enough to buy it, there's no question about that. But, we were talking in terms of what makes an artist; I think that the fundamentals should be like breathing to the artist, so automatic that he doesn't even know he uses them. What the artist has to say about the things that he experiences — is the thing that makes the great artist, and makes for differences in pictures. There is personality in the brush stroke, in the choice of subject matter, in the way the subject is handled and in the personal, intimate approach to that particular artist's work. It's something like a chameleon that changes color with the color of the background. It's something that is ingrained in the man and develops and becomes more and more a part of him as he grows, trying to solve the problem. There are no short cuts, at least there weren't for me; there's no way to cut through the lot and get to the other side; you've got to go around and touch all the bases; you must experience the various stages of growth. I can remember a time when I was studying — I felt that accurate drawing was the most important and vital part of the picture. It *had* to be. If the artist didn't show that he was the perfect draftsman, his picture probably wasn't worth very much. If the man didn't have a very good color sense and if there wasn't a harmonious relationship within the picture — that was the biggest fault. So, I began to think keenly; how do I express it; how do I make it come out of the brush; how do I make it go on the board so that it will tell the thing that I am talking about? So, a technique, a facility is maybe the most important thing as you begin to try to grow and develop. All of these things I'm saying are tied back to the fundamental principles of art that you apply as you learn. Gradually, as an artist grows, he begins to realize that he doesn't have to show on a picture that he can draw everything in sight. This doesn't solve anything.

BW: You obviously admire the work of Charles Hawthorne.

CS: Yes, I think that his theory of color and color relationships and area relationships is a pretty solid theory for a landscape painter. It's good theory for *any* kind of painter, but someone like myself, who is a landscape painter, finds his ideas particularly pertinent. I stumbled on

102

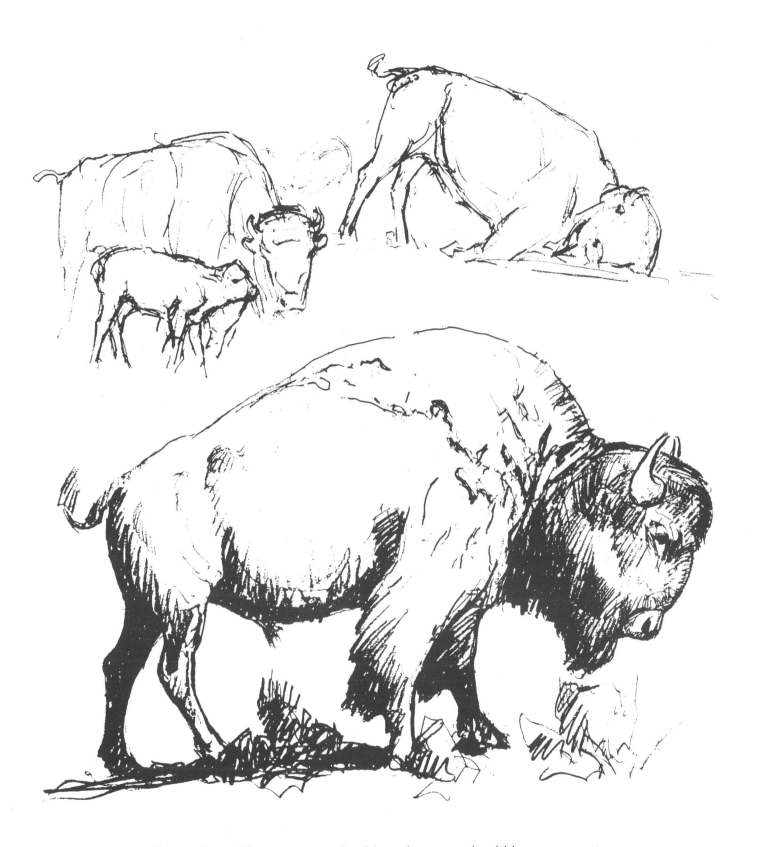

Schwiering's buffalo studies — "It seems most artists I know have a very inquisitive nature; they want to find out how things tick."

PRAIRIE NOMADS. *Oil on prepared board. 24x36 inches. From the collection of Mr. & Mrs. James Cizek, Hinsdale, Illinois*

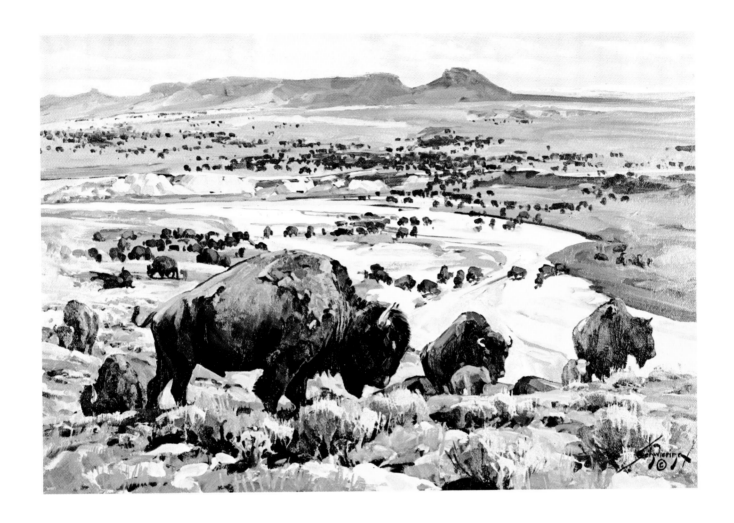

that book (*Hawthorne's Memoirs*) and became involved with some of the thinking in his classes; I felt it was a chance to visit and study with a very great man. I live alone; I have very few opportunities to talk with other artists, so I have used the books and prints and biographies and information about artists to help me grow. I study them, and when I land on something that sounds good to me, I study it carefully. It isn't as though I were just reading it, I read it as though I am talking with the individual. Especially during the winter, in the evenings, I read from some of my books. I have a lot of them so that, sometimes, I read from books about Thomas Moran or Cezanne or Monet, or maybe Van Gogh or Rembrandt, or some of our American painters, Winslow Homer, or a book like *The Art Spirit,* by Robert Henri. With these books, I can feel that I've had a chance to visit with that artist, or so it seems, to see how a particular artist's mind worked on a problem, how he analyzed it, how he approached it, how he solved it.

BW: Did you meet Gerard Curtis Delano when you were studying in New York City?

CS: He was a Denver man, and I didn't meet him until I came back to the West to try and make a living. He was already handled by Boutwell when Boutwell started to handle me — he was one of Boutwell's main artists. Gerry is older than I. I think he's an extremely capable, accomplished man. He was very charitable towards me, a young beginner, when I went into the gallery with him. Delano and I have had a very harmonious, cooperative existence, and I think he is a very fine artist.

BW: Why did you come to Jackson Hole to work?

CS: A pet theory of mine is that you should exhibit your work close to the source of the subject matter. I decided that I wanted to come to Jackson Hole before I was in college, when my father brought me here on some of his school trips. I was completely sold that this was the finest prairie, mountain, and ranch country in the United States — maybe the world. I knew then I wanted to come here and paint. When we did come here, making a living as an artist probably wasn't the easiest thing, because people weren't too conscious of art; others had tried it in here and most of them had failed because they just couldn't keep enough clientele to allow them to continue painting. They would either go out and paint somewhere else and return here in the summer, or they'd just drift away and paint somewhere else. I felt sure, with blind faith, if I came into this area and painted it as I saw it and experienced it, then surely somebody would see what I did and buy it, and then I'd be able to go out and paint some more. I say, oftentimes, the country and the mountains are my best salesmen; they're the first things in many cases that trap the mind of the visitor with the thought:

106

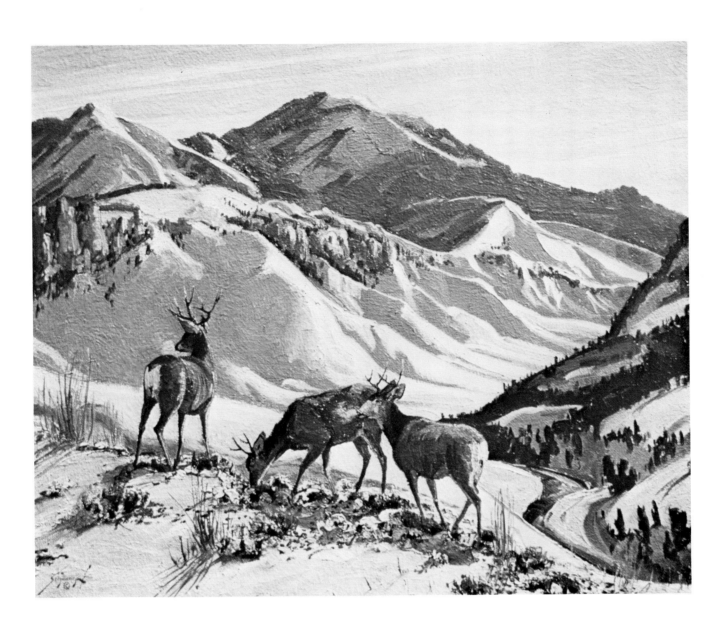

"Working the Ridge" 30" x 36" oil on prepared board.

"Gosh, I'd sure like to have something that tells me about these great mountains to take home with me." And it didn't matter if he was from Iowa, or out on Long Island, or in Chicago. Once in awhile they would stumble onto something I had done and they liked it because it recalled to them some of the feelings they experienced with the mountains — and my pictures began to sell. I am an impresssionist and paint moods; I don't try to paint portraits of the mountains, nor do I try to paint a literal statement of the mountains. I try to paint an impression of the mood of the elements as they play against the mountains, or as they play on the water. I feel keenly that one of my assets in working here was the fact that the mountains were so great that the customer was half sold even before he looked at what I did, if he was inclined to acquire a painting. This is why I think in many cases, an artist in planning his career — if he's got something he really wants to say — he ought to spend his time saying it close to that subject and not — if he can help it — travel back and forth to some distant place to do his work and his selling. My work is sold, of course, in galleries all across the country, so it will sell away from here. Gradually each year I began to get a little better, so that we could hang on for another year and go on and work. All I asked, really, was a chance to work. I'm thankful to God that somebody would buy them so that I could go on working. Right now, I tell every customer when he's made a purchase: "If it weren't for you, the customer, I couldn't go on and work." And I shake his hand. Many of them tell me: "Oh, no, it's *our* privilege to have something to make us recall this country, that makes us feel good." Well, I'm grateful for that, too.

BW: I could think of no greater challenge to the landscape painter than the Tetons.

CS: It's important for an artist, as he grows, to have a challenge before him that is almost insurmountable. In my case, it's the obstacle of trying to paint the wonderful impressions that I am able to see and experience. Doing this day after day, year after year, can't help but cause the artist to grow. And it's an important part of growing. It is *wrong* to produce the same picture in the same way every time you paint; this is a *stupid* way to paint. This is pot-boiling, because this doesn't make for variety or excitement in the artist's work. I've tried to aim my work at whatever instant or mood I've seen, and this is an awfully difficult thing to acquire — the ability to entrap a fleeting moment in time with a landscape. It is, I think, an important part of landscape painting. It involves the ability to recognize first the mood that you want to capture, and the facility to capture it so that you can work the rest of the picture based on that mood.

BW: You've been pretty involved in what is called "community affairs."

108

CS: I wanted this community to accept me as a man and a citizen, rather than as some artist who was in here to do pictures of the country without an interest in anything but the wonderful things that are here. So, I tried very hard to become an integral part of the community and assume the responsibilities of a citizen and do the job that you owe to your community. I think most of the people in the community accept me as a businessman who operates within the scope of the economy of the area.

Mary Ethel: Connie is gaining in strength and communicative ability every day; we can see the difference in the strength of his paintings, especially when compared to a few years before. His strokes and his touch just seem to be more masterful. He gets the mood that he's trying to get much easier and quicker than he used to. His technique doesn't seem to change greatly, and yet, you can see differences in it when you compare what he's doing now and what he did a year ago. I don't know much about it; I just know I can look at them and see a difference. I suppose it's because I've watched it so closely, and whenever we've been in the cities he's taken me to the museums and, as he studies a picture, he points out things that he thinks are good and the things he thinks aren't good. I picked up information little by little; I'm not even aware of it. The only way I can judge a picture is to look at it and know whether I like it, whether I don't, and what part bothers me. I tell *him* these things; he says it helps him; sometimes he changes it, sometimes he doesn't. That's the only way I can help him is to tell him what I *feel*.

BW: So you think that Connie has succeeded in . . .

Mary Ethel: I feel that he is successful. I sometimes think that Connie is a bit too humble. He protests all the time that he isn't good enough to get this and he hasn't progressed far enough; I keep telling him that he shouldn't be that way. I think his work is improving and he is getting noticed now, and I tell him he should accept it graciously instead of protesting all the time. Maybe *I'm* the one that's wrong. I certainly wouldn't want him to go around being boastful and thinking he was the "big it." But I don't like to see him keep saying, "Oh, I'm not worthy of that," or "I'm not good enough yet." There should be a line somewhere. I feel that he has made great strides. When people buy his pictures, they are also appreciative of his canvases and the feeling that he gets into them. We get many letters that say: "We love it, we feel like it's a window in our room. We feel like we're right there, looking at the mountains again." I think that is one of the greatest compliments that people can give him. Everyone looks at a picture a little differently and sees different things in it. I'm prone to look at some insignificant detail that bothers me; most people don't do that, they look at the whole picture; they see it in one big mass. I think that I've slipped into the habit of looking at them a little more critically because I try to help him

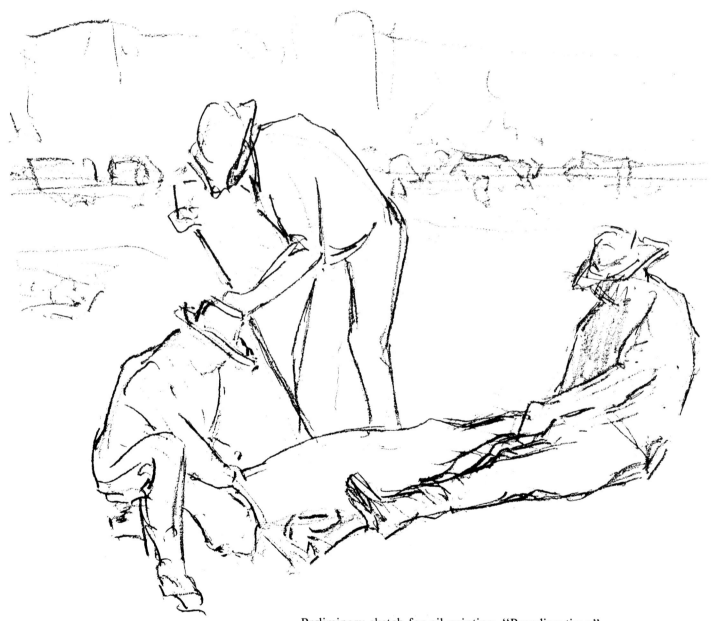

Preliminary sketch for oil painting, "Branding time."

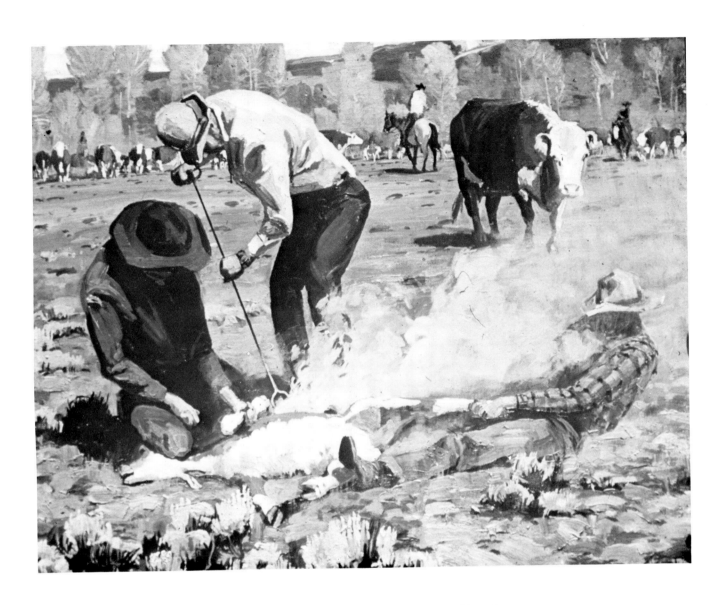

"Branding Time" 30"x36" oil on prepared board

pick out things. If I think he hasn't worked out a sagebrush or tree I tell him. I know that this isn't right. He's trying to become broader in his approach, and get the essence of the picture with fewer and bigger strokes. That's the artist, and I'm the lay person that thinks he has to put every little thing in. But, I'm getting better, I think.

BW: Connie has referred to you as "the ranger."

Mary Ethel: He's always called me that, because I protect everything so. And, since we've had so much about the astronauts, he calls me "Mission Control," too. He thinks I'm too particular about things; keeping the house cleaned up and mopping up the footprints after people have been in here to look at pictures. But, he accepts me for what I am.

BW: You're the one in charge of customer relations most of the time, aren't you?

Mary Ethel: Yes. The customer is the thing. If we didn't have the customer . . . every person who comes to the house we treat as graciously as we can, showing them all the paintings they want to see; we visit with them, become friends with them. We feel that a satisfied customer is our best salesman. We have many people who come back year after year just because they feel welcome; we show them around and tell them what Connie has been doing. We feel we are very fortunate in being able to have our home in such a beautiful spot. I can remember when we first came to Jackson, Connie found this spot, and every week we would pack a lunch on Saturday and Sunday and come out here and sit on the knob of the hill and look at the mountains and talk about what a wonderful place it would be to have a home here. Of course, we didn't actually believe that our dream would come true; so we really do feel that our home here is just like a dream come true, like our fairy Godmother has come and tapped us on the shoulder and helped us make everything come right. We appreciate it very much, because we both have put a lot of hard hours in building the house and decorating it. I made the drapes in the studio and the first drapes we had in the bedroom. Now we've been able to buy new ones for the living room. We picked out everything; we had no help in decorating it; we just did it the way we thought we would like it, and are happy with it. We've entertained a lot of people; I don't know anyone who has met any more interesting people — with all kinds of abilities and interests, from all walks of life — than we have.

BW: Let's talk about your feelings on conservation, Connie.

CS: I believe in the National Park Service's philosophy on preservation and most of the things the park stands for I'm one hundred per cent in accord with. If I'm critical of anything they do, I would be critical of

that no matter who did it. The national parks are a very great service and boon to the American public, maybe eventually to the *world,* because we certainly have a policy of enshrining and preserving some of the most wonderful phenomena that exist in our country. It's not too late to preserve that which is great; at least, we're waking up to that . In the Tetons, this all started with John D. Rockefeller, Jr. Horace M. Albright initially gave him the idea of coming into Jackson Hole to look at this country, with the thought that maybe it would be a great area to preserve. Mr. Rockefeller came into this area and decided that he agreed; this was a great natural wonder and it did deserve preservation. So he systematically set up an organization to go about buying the land. At first, no one knew who was buying the land — just that it was somebody willing to buy it for a good price. In many cases, the ranchers here wanted to sell, because it was a good way to make money out of their homestead property. As more and more land was bought, there was a feeling by those who had already sold that they didn't get enough for their land, because the later people got more money for theirs. A strong animosity grew within the valley because the local people felt possessive of the land; it was their land and it was their beautiful country and their hunting grounds. They didn't take to the idea that outside government forces were going to take over and make a park out of it. That strong, bitter feeling existed for a long time; it doesn't exist nearly like it did, because it's becoming apparent that John D., Jr., did have the interest of the American people at heart. The land that he acquired and gave to the federal government is preserved in an enviable state, when you consider what has happened and continues to happen in the area just outside the park on private land held by private individuals; shacks are going up with all kinds of signs all over the area about where to sleep, where to eat, where to get your car fixed, who sells insurance, and all of that stuff. Then, when you step into the national park area that is controlled by the federal government, you're in a clean, sign-free area, except for directional signs which tell you what you need to know about the country without a lot of fuss and feathers — no tourist traps, is the best way to put it, or snake pits, or wolf dens and old car displays. It is a wonderful, scenic attraction. I am grateful we own land in the park. I am on the museum board which has to do with their naturalist program policies (the Grand Teton Natural History Association). It's a civilian service; others are Dr. Don MacLeod, Harry Weston, and Dick Barker, all local men, the Park Naturalist, the Chief Ranger, the Superintendent and their assistants. Most generally our duties are rubber-stamped. When a naturalist wants to do a thesis on elk or moose, brook trout, the Snake River Cutthroat, or something like that, we assist them; we sometimes put up the money to publish the works that they do, or at least we give them a grant that will aid them in doing better work. Our board is oriented toward

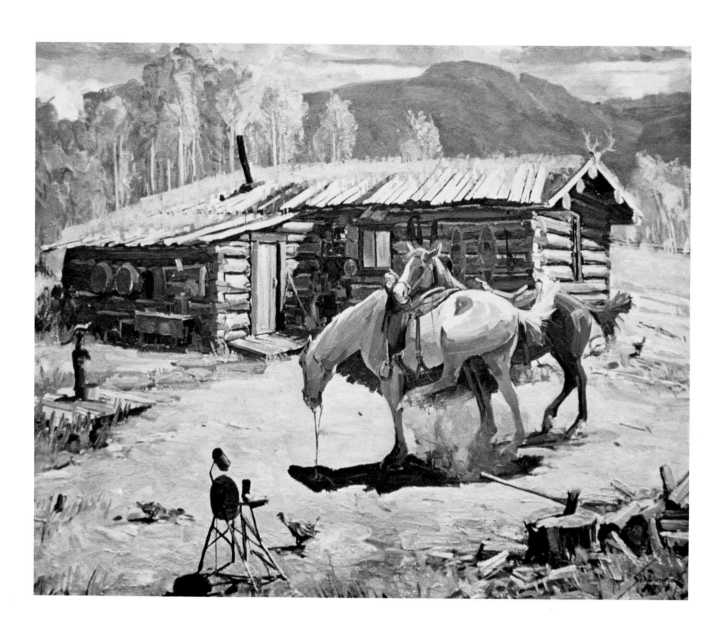

"Coffee Time" 30"x36" oil on prepared board

helping make this park better understood by the general public and by the naturalists, or biologists, or the man who is interested in the geology of this area. The other local men and I are keenly anxious that the park makes some effort in saving some of the early homesteads that are still left in the area. The park is a big bureaucracy, and they have many ways of shoving the decision down another track. They are not opposed to preserving anything, but they also realize that once they take on a program of preservation, they are hooked. They have to do the job in a first-class manner and they are reluctant to preserve too much — that means they've got too many irons in the fire. They have people who are supposed to help them select the things that are worthy of preservation, and many of these people are oriented toward places where things have happened; for instance, if George Washington slept there, it might be a good reason to preserve the place. Or the horse thief cabin up here that we call Cunningham's place, because there was a confrontation of horse thieves up there and they were killed — so that's an *event*. We contend that this isn't the *only* thing that is worthy of preservation; that a way of life occurred here in this valley early — when the homesteaders came in and settled it; and they eaked their way of life out of the valley. This is fast slipping away now, because the valley, especially in the park area, is being oriented toward park visitors . . . going back as much as possible to the natural state of the land as it existed *prior* to man's arrival on the scene. In general, they are interested in obliterating the influence of man in the park. We feel that here in the West, and especially where history is so recent in Jackson Hole, where you still have some of the original homestead buildings, that heritage ought to be retained. Our stand has involved us in quite a lot of heated arguments with the park people. We are impatient with the wheels of progress within the park, impatient to see what they will decide to do. I'm oriented towards the park's activities — they know that I'm sympathetic with their programs, and they know that my love is as great for this country as any love could be with any man, it wouldn't matter who. My desire is only to make the country better understood by everyone. It's a wonderful thing to have this great, free, wild and powerful country available to the man who lives in the flatlands all over America, the man who has almost no experience with great mountains and great outdoor activities. This isn't an oddity of nature, like Yellowstone Park; this has the grandeur, power, and majesty of nature's creation. You feel it keenly, if you let yourself.

BW: You mean some people don't *let* themselves enjoy the park?

CS: Let me illustrate. I think that anyone who has lived here in the valley has had something similar happen to them when they were out somewhere; the park has provided many beautiful turnouts where people can stop and get out of their cars and see beautiful maps of the

mountains, so they can identify the peaks. Someone who is pretty calloused, who may be interested in covering another 800 miles that day, will stop and say, "Well, what's there to see around here?" This has happened; I've heard it myself. They just don't get the message of the mountains. Then, there are many people who are in such awe of the mountains that they are afraid of them; they feel depressed by the mountains. It's strange. I would think that, if you lived in the city you would feel depressed by the big buildings caving in on you, trapping you in the dirt and filth of the city. But, it's just the way you are mentally oriented. I think a lot of this is a philosophy that comes to a man who has been privileged to live and grow up a part of this western way of life, in this great open, western country. It isn't really fair to say Wyoming is the best, but I have a strong affinity to Wyoming, because I spent the formative years of my life here. There's a longing to convey the things I feel about this to other people. This is keen within me. Most creative people — artists, musicians, actors — leave this country and go somewhere else to do their work. They go to New York City; that's the Mecca; or to Hollywood.

BW: You might be credited with beginning a native Wyoming School of Art.

CS: It's more of a cultural growth than a school. Jack Rosenthal (manager of a Casper television station), said a lot in one of his editorials, in effect — "Wyoming has a long way to go in accepting its position in the nation, when they will appropriate $100,000 for grasshopper control and not a dime for culture." It means quite a lot. This is a materialistic state; it's just beginning to break the eggshell and realize that there is culture available here; that there are cultural things that are ours that we should take pride in; that material things are not the end of life. Creative people are occurring, new ones; they are occurring all over the state of Wyoming in all fields; it isn't *all* materialistic. That is, how many grasshoppers are you going to kill and how many grubworms are you going to get, or what will your oil quota be — that sort of thing. Wyoming has a big problem with its creative people; they will continue to leave unless they are encouraged to stay. And, it's not that the state isn't paying any attention — I've got great support in the state. But, the elected body must be concerned with the development of our state's creative people. Someone will have to champion the cause, or we shall continue to have a cultural gap.

BW: You are pretty frank in your admiration for John D. Rockefeller, Jr.

CS: As I look around the areas in the Rocky Mountains or the other places that I've been, I've become more and more impressed with the great service that this man and his family have given to our area —

and to many others. For the vast open, uncluttered spaces without hamburger stands and billboards and promotional developments and all the trash that follows many of the national park developments — I'm grateful. The people of America should be grateful. I realize that people have a tendency to overuse the thing that is preserved for them. The park service has the challenge and the charge of saving this great area so that people generations from now will be able to enjoy this country and see it in all its beauty. It's hard, because a lot of Americans are pretty callous; they have a tendency to use the country like they use Kleenex; they just use it and throw it away. We cannot fritter away these wonderful natural resources even by *over-loving* them; there's a problem of care that is a very delicate one. I remember once when the park service was planning the rock parapet at the Snake River Overlook, near Dead Man's Bar; I happened to be painting there; it was way off in the prairie at that time; there was no road. These men pulled up, top park people, with the superintendent at that time, Frank Oberhansley. Frank was a great planner; he wanted the certain areas of great interest to be designed so that people could stop and see them. Eventually, they came over to where I was painting and asked my opinion on the way I thought a scenic lookout should be designed. They told me that they would propose a large parking lot off the highway so that cars could get off and people could stand in a large rock parapet above the tremendous dropoff to the Snake River. I, of course, looked at it as an artist, and, completely selfish and nonobjective, voiced heavy opposition to this rock division that would be a foreign thing in that beautiful spot. My contention was that the foreground was wonderful the way it stood, with all the sage, rock, and rough edges. Frank said — "Well, Connie, you got to remember that we're going to have millions of people on this spot. It isn't just you. It isn't just one or two like you. The millions who stop here will overrun it; that's just human nature. If we don't limit them as to where they can go, they will tear up the ecology in the area, because they will go just everywhere. So, even if you think it's a silly thing to have, we're going to have to put it in." As I reflect back on it — and see these millions of people come through — I think it was a very fine idea. I really didn't know the size of problem these men face in deciding how they can preserve the area for posterity; it's a big problem. In 1968 I happened to be in on a discussion with Bates Williams, superintendent of the Canyonlands National Park, after I'd been in the Chesler Park area for two weeks. He asked me to come by before I left so that I could visit with him. He was the kind of man who looked around. This time my approach to the wild country was entirely . . . no, it wasn't entirely different, because, when he asked me what should happen in the Chesler Park area of Canyonlands, that some people wanted to develop a road right into Chesler Park — I'm sure he felt as keenly about the precious wild quality in this area as I

117

Schwiering, the ecologist, surveys the land he struggles to preserve.

did, and my recommendation to him was to build a parking lot just off the highway down in the valley away from the Chesler Park area and make the approach to the park a foot trail, so that anyone who visited there to see that great, wide, wonderful country would have to walk or ride a horse, because this is the real way to see and enjoy that canyonland country. We talked about the kind of trails. After having worked up in that area for about two weeks, I said to him, "I'm sure you'll have no real problem with people getting off the hard path, if you provide one with the things you want them to see. If you provide the path, and ask them to stay on the path, they will stay on it — because it wears you out to walk in the sand." I feel sure that his sympathies were the same. I only recall this to show you that it's a comparative thing; it's happening everywhere, where national parks are being developed and where scenic wonders are being discovered. If they aren't preserved, they are being used and worn out. We've had plenty of occasions to experience this with such a thing as the Redwoods. That was a great step, and a very difficult step. I'm quite in sympathy with most of the things these various conservation organizations are doing — but I'm not a purist, because I believe in adequate public use. So, I wouldn't endorse any one plan; I will endorse parts of all plans. I think it has to be done with some temperance, because there's a limit. If you close off an area and lock it up as a wilderness area, you're locking it up so that just a very few can get in and enjoy it — the very few are the privileged few, they aren't the general mass of people who need this great release and the great replenishing of the battery — the things that happen when you associate yourself with the wonders of nature. I'm sure this temperance has built up in me over years of association with this environment, and with knowledge of the problems that are confronting the park people every day when they involve themselves with planning use of the land.

BW: Let's get back to your thinking on John D. Rockefeller, Jr.

CS: I think the park in its physical being is a fulfillment of his dream to give something as precious as this to the American people and to the world forever. I'm sure that, from what I've read about him and from what Red has said about him, that he was a man who appreciated the importance of everything in nature, everything in life; he felt its place was needed and important. I can remember many times, Red would talk about how thoroughly Mr. Rockefeller would investigate everything he saw as he went through the country. Red would tell me, oftentimes when he and Mr. Rockefeller were riding out on the trail, he would say, "Red, how long is it going to take us to get back to camp?" Red knew pretty much how long it took. He'd say, "Well, I have half an hour, then, haven't I?" He would just dismount and go and sit on a log out in the middle of the forest, alone. And just sit and contemplate the

119

trees, rocks and birds, and all these things around him. This man fully appreciated people and their loyalty and the wonders of nature that he was lucky enough to enjoy. Red probably just sat off with the horses and had a smoke. I know that Red felt it was a precious time to him and he didn't want to intrude on this man's love and thoughts for the country. Red just loved Mr. R. He told me once of a trip that he had with Mr. R. up on Jackson Lake; Red was his guide; this was around 1950. Red said he can remember Mr R. sitting in a boat on the lake, and there was the chief ranger and other people in the boat with him. They had been discussing the park. Mr. R. said, "Wouldn't it be wonderful if we could provide some kind of accommodations so that the average traveler coming through this country could stay and enjoy and partake of this country?" At that time there were no accommodations other than a campground at the northern end of Jackson Lake, and a small resort. His desire was a humble wish to make it so that everybody could enjoy the things he felt so dearly, so keenly. Jackson Lake Lodge and Colter Bay were the two direct results of this basic thinking. I happened to be in Denver at the time this broke, and I can remember Alexis McKinney (assistant to Palmer Hoyt) saying to me — "Connie, one of the biggest things broke today in your region that's ever going to happen up there. The Rockefellers have announced that they are going to build a lodge and accommodations for the traveling public." My reaction was of surprise, because I was a little bit local in my thinking, and I didn't react with such great joy at the thought of having some of the spots that I liked to go and paint occupied by lodges and camp grounds. Where the lodge is was one of my favorite hunting grounds; I used to paint on the ridge where they built the lodge; it had a wonderful view of the valley and the willow flats that overlooked Jackson Lake and Mount Moran and the whole range, views in every direction. It's had great economic impact on this area. I think there were just over three million people through here last year. A little of that has rubbed off on everybody, including me. Remember, when I came in here there was only one other artist. Two years later I started the first art gallery the town had ever seen. Well, now there are eleven galleries showing work of artists from all over the West. It's a wonderful thing to have happening. I'm so pleased that it's becoming an area that is art conscious, concerned with the beauty that is here and calling it to the attention of the other people. I've always felt since the time I first came here that this was going to happen; I'm happy that I lived long enough to see the development.

BW: I noticed during my first stay at Jackson Lake Lodge, in 1966, that you had quite a display of reprints of your work, as well as your paintings.

120 CS: We've depended on the print business to augment our income. It

isn't really as important to us as it was earlier. Three or four years after I got started here, I began to try to sell notes with reproductions of my paintings on them. Dad helped me by buying the reproduction rights to some of my paintings and using them on summer school bulletins — as far as he was concerned, the plates had served their purpose, so I acquired them as part of the selling price, and used them to print small notes and began to sell them through the stores here. Along with that, I ran into a situation with the Cocks-Clark Engraving Company in Denver. Truie Clark somehow got interested in the fact that I was painting this country and used one or two of my pictures in their calendar each year. Truie approached me on a reciprocal sort of agreement, where I would have the complete fine arts rights to the print after its use on their calendar, plus the fact that they gave me a certain number of prints as part of the contract. Truman E. Clark — he's been a fine guy to deal with. Over the years we must have produced 20 or 25 reproductions 9x12 in size, of my paintings. I developed a fine print market in this valley that's exclusive to me; there's no one else that can be in this business with my work. So, while it's been a lot of work to put the elements together to make the prints a real presentable package, we devised a way of doing it and we have for years sold them in most of the gift shops here in the valley. Incidental to this, I developed a method of mounting my prints on textured board and putting a small frame around them so they would look like small paintings. They are sold for a minor profit, but it does give those who can't afford a painting the chance to have something that is pretty representative of what I do. Oftentimes it starts the process of thinking about ownership of something I've done, and many people who buy the print may come back six or seven years later to buy a painting.

BW: How long do you reckon you'll keep working?

CS: An artist never thinks about retirement. His idea is that he will paint right up to the time that he drops over. The production should get better if he works at it and keeps trying to do better with each painting. His last one should be his best one.

DRIFTING DOWN. *Oil on prepared board. 30x36 inches. From the collection of Mr. & Mrs. Preston S. Parish, Hickory Corners, Michigan*

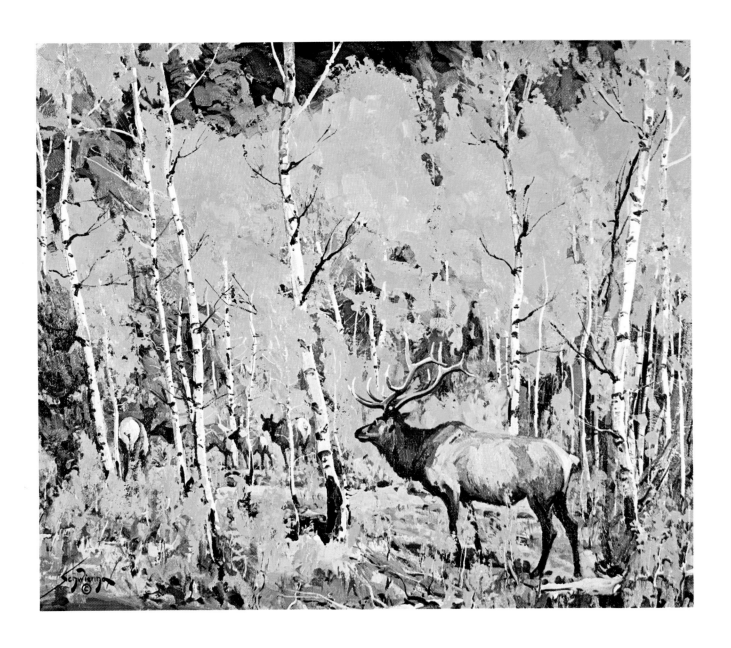

WINTER'S HAND. *Oil on prepared board. 30x40 inches. From the collection of Dr. & Mrs. Donald G. Stockman, Salt Lake City, Utah*

124

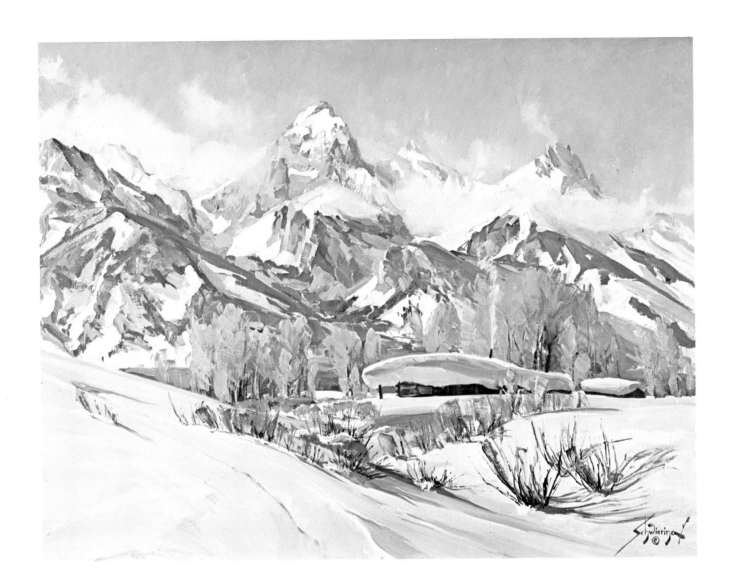

ALPINE GARDEN, *Oil on prepared board. 20x24 inches. From the collection of Mrs. Jack E. Haynes, Bozeman, Montana*

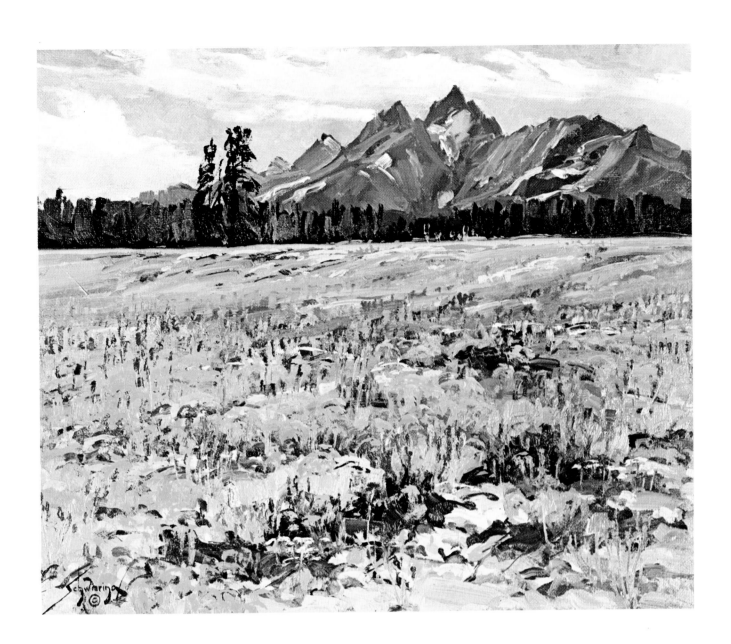

WHEN COW PUNCHING GETS ROUGH. *Oil on prepared board. 30x40 inches. From the collection of Mr. & Mrs. William A. Spencer, Lake Forest, Illinois*

128

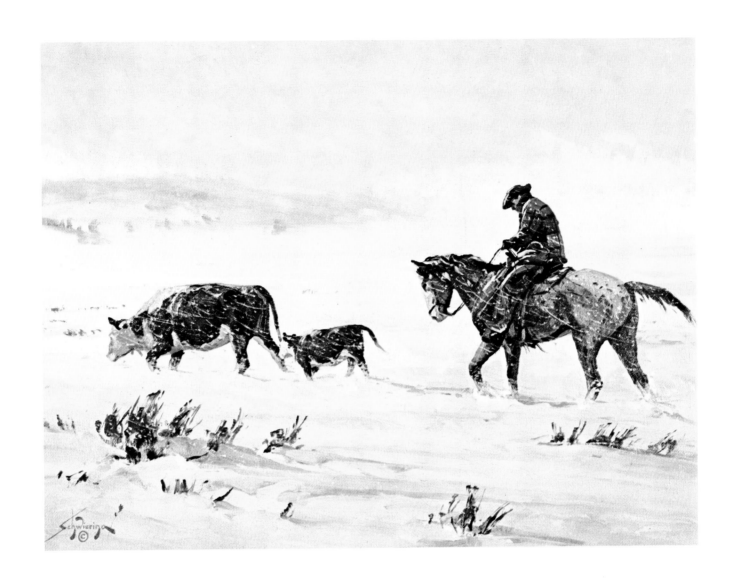

The artist does most of his painting in a small studio built behind his home. Even some of his closest friends have never been inside. (Photo by David Laustsen)

THE SCHWIERING TECHNIQUE

"When they hang you, they got to hang you good."

So said Carl Rungius, dean of America's big game painters, when Connie visited him in 1952. Sending large pictures to art shows was a part of Rungius' technique, as important to him as any of the other elements in his painting style.

When an artist produces something he wants to have his name on it, legibly so that it can be seen and easily read. Style is the quickest way to recognize a man's work, among those who understand the man's work other than his signature. Connie wanted a symbol that attached him to Wyoming, his home. Will James used the pony track and Charles Russell used the buffalo skull. Connie decided to use the Indian Paintbrush, Wyoming's state flower, a stylized version with a little tip of red.

An artist wants a surface that is compatible with his method of work. Many artists work on a surface they have to fight with. Paint scrapes off, or the surface is so porous it soaks up paint as soon as the brush touches the surface. Connie developed a method of preparing his boards that made them "friendly" to the paints. Initially he uses a forest treated hardboard. The rough side of the board gives him a feeling of a canvas background which he can either preserve or paint out easily.

He begins with a one-eighth inch treated hardboard. Then he underpaints the board with Moore sani-flat house paint, a good titanium white that dries with a hard finish. Schwiering applies a coat to

the rough side of the board and sands the board as soon as it's dry, knocking the tooth off the surface. Then he applies a second coat and lets it dry, sanding it again with a fine sandpaper. The third coat brings out the texture of the board through the paint. He allows some of the brush strokes of the preparation brush to show. He can incorporate the brush strokes into his painting or not, depending on the painting subject.

The boards dry in his basement for about a year before he works on them at all. The surface is thoroughly dry and impervious to any damage that might occur from applying paint on the surface and having it shrink afterward. These boards are toned with oil paints and a thinning medium, Taubes Copal Varnish, an all-purpose varnish containing the finest quality Congo Copal resin. He uses Grumbacher Copal Painting Medium No. 587 as his painting medium. The surface he applies for the original background tone is an oil painting surface, but it's toned to many colors — not like painting a house.

He tones the boards with a variation of colors so there's vibration even in the tone color. When he's finished, he has a series of boards that are many tones of blue, gray, warm ochre, and warm sienna, close to the main value in the prospective subject material.

He takes 10 or 20 boards with him when he goes out to paint. When he selects the subject, he also picks the board that is closest to the big key value that is in the landscape. Sometimes it's a mountain, sometimes a field of flowers; then it might be the sky, the color of water if it's a stream picture, or the color of the background that's going to be used for a horse picture. If he doesn't have the right tone for the picture, he paints one that is the right tone, so he has a beginning surface to work on that keys the picture with the big, main value. It is a very fast method of visualization, assuming he's able to get the big forms drawn on his board and has the general composition planned.

When the mood comes on the subject, he's ready to paint and doesn't have to argue with a white board. In a matter of 15 or 20 minutes he has suggested enough of the key values in the picture that, if the mood goes away, he can carry on.

Winsor-Newton paints are the finest of permanent colors, Connie claims, and he uses them continuously. As for his use of color, it is second nature now, somehow found instinctively on his palette, without a glance. The only time he's bothered, Connie says, is "when I run out of paint on the palette and have to go look for a color."

Schwiering uses no greens in his palette, arguing that the commercially prepared greens are too foreign to the greens he sees in nature. Thus he uses more blues, two yellows, some burnt sienna and Indian

132

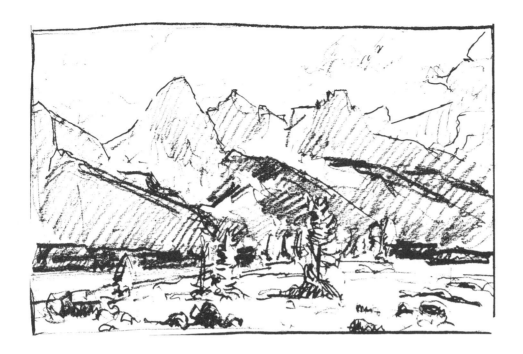

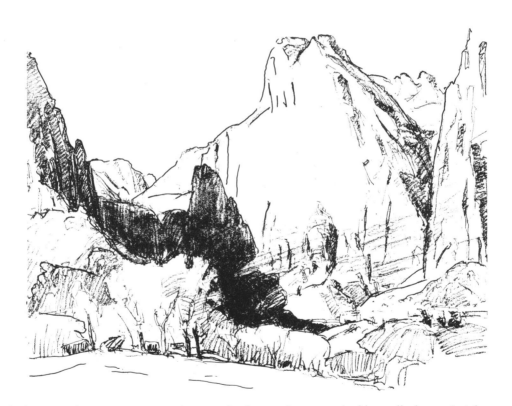

Schwiering somehow can capture the mood of a setting, even in his preliminary sketch.

and light red to create green tones with the blue. He uses a cadmium light red with the blue to create deep blue tones. He might even use a blue with alizeran crimson to create a dark, luminous shadow, like that in a pine tree. He feels that even the shadows in a painting should be luminous, "because light gets into the shadow area by reflection." His blues include French ultramarine, cobalt, cerulean and manganese blue.

Other colors in his palette include alizeran crimson, burnt sienna, light red, cadmium red, yellow ochre, cadmium yellow light, and white. There's no black in his palette. Connie feels that black is a fine color, but he can get the grays he needs by using a combination of the other colors and the umber tone.

The artist must know the possibilities of the colors as they combine with each other and as they combine with white. Raw umber and white, for example, when combined produce a beautiful warm gray, like the color of clouds. Or the color may be used in a quaker grove, in the foliage and small branches of a quaker tree. He might add a little yellow to warm it up or a little blue to green it down, but the technique must become so secondary that the artist isn't even thinking about where he'll find it on his palette. Connie says the process isn't a formula approach, but evolves after hours of trying and failing. "Never follow the same path to the solution," he says, "or you'll never grow. If you don't experiment, your work becomes stagnant and unexciting. Nature is exciting." The artist's effort is an attempt to translate the excitement of nature onto a surface in such a color and form that others will experience the same kind of excitement the artist feels.

Connie uses a Grumbacher copal painting medium. He says it's a wonderfully fine vehicle to work with. Before he begins to paint, Connie brushes this medium over the entire board and allows it to stand for thirty minutes. This makes the surface more receptive to the paint. He uses it very sparingly if he wants a heavy, impasto effect or he uses it fluidly for a thin effect. Often the artist wants to create the illusion of a great smoothness, a distance effect. Skies, especially, shouldn't be painted with big, heavy brush strokes. A sky should be painted so a bird could fly through it. When the artist is expressing trees or rocks in the foreground, then he uses the paint almost as it comes from the tube, with very little medium. Then he creates the illusion of texture by allowing the brush impression in the paint to show.

Connie uses sables, flats, "and for the most part the biggest brush I can possibly find to do the work." The size of the canvas limits the artist's choice of brushes. Rather than select the smallest brush to tell the story, he tries to use the biggest brush so that his work is broad and free. "The little details are lost, anyway, in a picture," he says. Often the artist tells people he applies paint in any way that he can, so as to

The artist's paintbox is always neat and orderly. "This saves time," says Connie, "when I go to look for a color or brush." (Photo by David Laustsen.)

Connie shapes his brushes into an assortment of widths and densities to experiment with texture. The brush he holds here will be used to paint grass. (Photo by David Laustsen)

create the illusion he's after, "whether that means I've got to rub it with my little finger, my nose, a rag or a palette knife or a stick." He has discovered from experience that a rag will sometimes soften a sky and pull it together, making it loose, airy and free.

An impressionist tries to create an illusion, touching the essence of the subject without embellishment and overspelling. When Connie first began painting in Jackson, John Scott Williams, a mural painter from New York, examined one of his paintings closely. The picture showed a mare and colt crossing the Little Laramie River, the colt's first crossing. The artist took a point of view down on the stream bed looking up past them. They were silhouetted against some cottonwood trees; it was in the fall. In the stream bed in the foreground were the cobble rocks that lie along all river beds. Connie painted the rocks very carefully, and Williams commented, "When you learn to paint all these rocks in one or two strokes, showing only one or two individual rocks, then maybe you'll become a painter." Connie learned quickly.

He doesn't worry about the little areas in the mountains, the "little bumps and things that occur in the mountain mass or in a tree or face. If you get the big masses right, the rest of it will take care of itself."

Once he was sitting in his gallery in the Wort Hotel when some mountain climbers traced their climb route in one of his paintings. Though he knew nothing of the route and paid little attention to the characteristic rocks, they were able to discover their entire route in his painting. For them, his illusion was complete.

Connie uses a palette knife in his work extensively. But he doesn't use a mahl stick, claiming, "If I find that I have to do something, I've got a good, steady hand. I approach the thing with assurance and lay the brush down and go to work. If I do need help, I lay the brush over my arm."

Connie claims the easel is probably the weakest part of any artist's equipment. Commercial easels aren't made for artists who work outdoors, but for someone who works outside once or twice a year. "They're pretty punk," he says, "and not made for a hard-working artist."

He began using the back of his jeep to hold his paint box, after the wind had blown many of his boards over. He attached an easel to the back of his jeep, so that he could use the platform of the jeep as his paint stand and palette, clamping his board to the easel like he does in his studio. That arrangement allowed him to work with all the freedom he has in the studio.

136 All his pictures are completed in his studio. Connie claims the

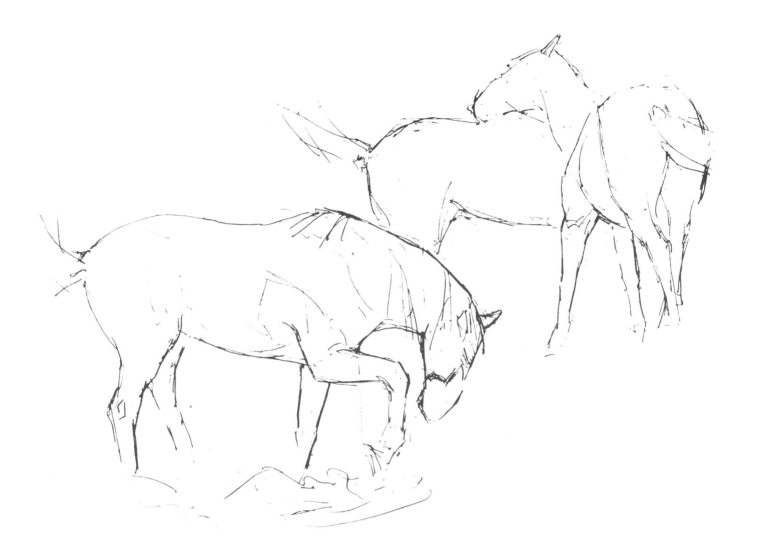

Preliminary sketch for "Switchin' Flies."

artist can't make the final judgment of the picture when he's out in nature. "The important thing," he says, "is to sit back quietly within the confines of your studio and analyze each picture to see if it has created the illusion you wanted. If there is some weakness, you edit and rework it."

When working in his studio, he's usually alone. He listens to chamber music or good piano music, claiming the music helps his mental attitude. "There are many things about a work of art and music composition that are very closely akin," he feels.

The Schwiering technique is a study in logic, but it goes much deeper than that. With inventiveness, intensity, and bold individualism, he has succeeded in using his techniques to translate the message of the mountains.

He speaks in a universal tongue.

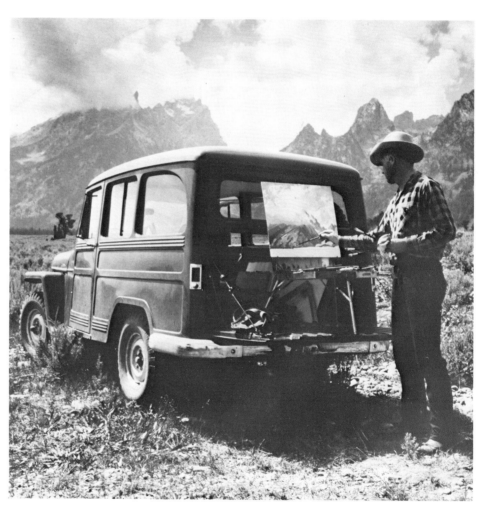

Schwiering and his self-fashioned easel, clamped to the rear of his jeep.

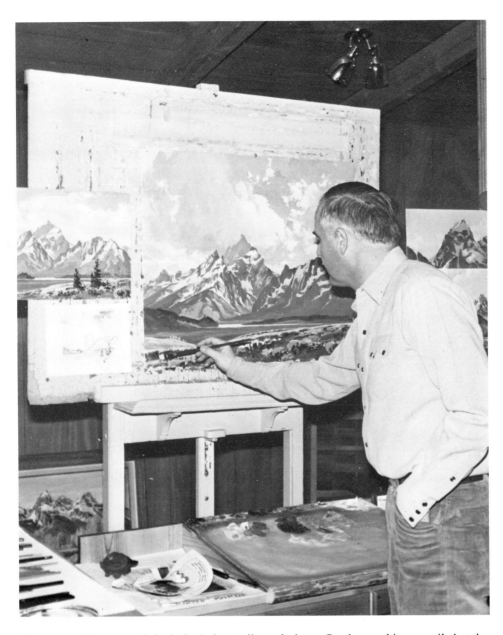

This photo illustrates Schwiering's in-studio technique. On the easel is a pencil sketch, above which is a slightly larger oil sketch of the same subject; both are used as reference by the artist in completing the finished picture at the right center of the easel. Note the glass palette, and to its left, squares of newspaper used to clean his brushes, "I'm fascinated by the colors I get even when I clean my brushes," he says. "You look and see fantastic butterflies of color when you unfold the scraps of paper."

139

SWITCHIN' FLIES. *Oil on prepared board. 30x36 inches. From the collection of Mr. & Mrs. Gerald D. Wilson, Pasadena, California*

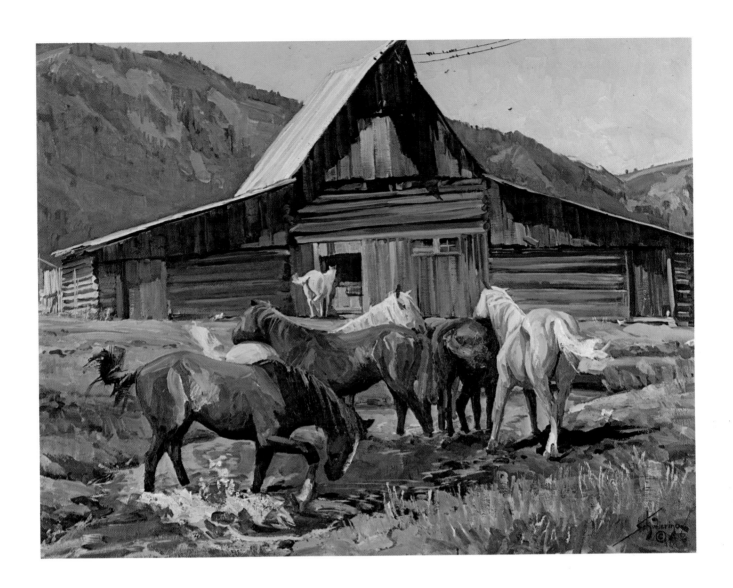

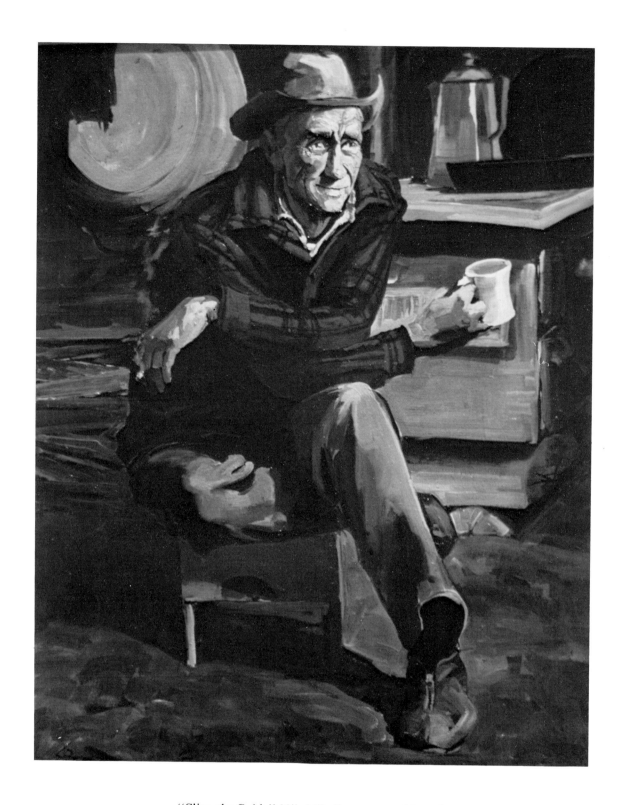

"Slim, the Guide" 30"x36" oil on prepared board

These three sketches show the artist's technique . . . number one is a rough, rhythmical drawing that merely arranges the subject anatomically. Number two carries the idea further. Number three is the completed sketch, and would be used for the final rendering of the painting, "Frost Etched."

143

FROST ETCHED. *Oil on prepared board. 30x40 inches. From the collection of Dr. & Mrs. Donald G. Iverson, Cheyenne, Wyoming*

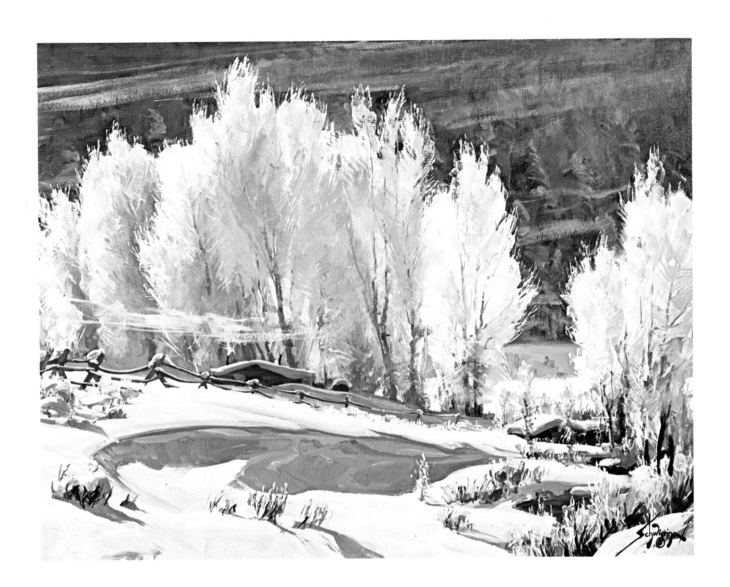

SPELL OF FALL. *Oil on prepared board. 30x40 inches. From the collection of North Shore Savings & Loan Association, Milwaukee, Wisconsin*

146

FAVORITE SPOT. *Oil on prepared board. 30x36 inches. From the collection of The First National Bank of Laramie, Wyoming*

SPRING BRANDING. *Oil on prepared board. 30x40 inches. From the collection of Mark Davis Moorman, Atherton, California*

COMPARIN' NOTES. *Oil on prepared board. 30x40 inches. From the collection of Dr. Robert H. Lamb, Salt Lake City, Utah*

CHAPTER
SEVEN

WE GATHER TOGETHER

Until 1957 there was no organized effort by Connie or his fellow artists, Paul Bransom and Grant Hagen, to teach students. Each of them took individuals out in the field, but all agreed their work suffered when they took time away from their efforts for coaching. Gradually, however, the three artists succumbed to the pleas and formed Teton Artists, Associated.

Paul Bransom was a leading New York illustrator, specializing in animals, who kept a summer studio on the Bear Paw Ranch, while Grant Hagen was a skilled landscapist, naturalist, and animal illustrator. The three of them agreed at the outset that theirs was to be different from any other art school.

When a student studies in a formal school like the Art Students League, he gathers a working knowledge of drawing and painting nudes and draperies and still life, but he has little chance to work with landscapes or live animals under supervision. Teton Artists, Associated gave the students a chance to work outdoors with artists who were experts in varied fields.

The students were different, too. Some were in the area for only a couple of days at the most. Connie and his fellow artists provided instruction for them as well.

Discovering their students didn't like to hit the trail at daybreak, the professionals set a ten o'clock starting time, which seemed to please everyone. With their lunches in hand, the students struck out for class,

155

learning from their instructor the boundaries of their painting site. "Each student wants to choose something that is his own little spot," says Connie. "I've had students wander so far I forgot they were with our crowd. We had to get over that."

After the students settled down, Connie recalls, the instructor talked with them for about a half-hour, except the former students or professionals who were turned loose to paint whatever they wanted.

"In painting outdoors," Connie told the assembled students, "it's more important first to analyze the material around you in terms of shapes and forms. I realize it's difficult for you to conceive of the basic shapes in these big mountain forms. You'll have a tendency to see things in detail rather than seeing the overall mass that's there. First you must get a mental picture of what's out there and reduce it to a proportionate scale. None of us is lucky enough to have a canvas as big as all outdoors. Use your hands to frame the material, to find out how much width of the mountains you need in order to get the whole sense of the mountain mass. Don't try to do just a little slice through the mountain. This leaves much to be desired in telling the story of the big mass you're working on."

Some of the students took notes as Connie continued, "You have to select a place in the square or rectangle of canvas to place the mountain. First do a simple line drawing that shows the basic form, in proportion. Very much like shooting a rifle, you need an aiming point so you won't misjudge distance. Extend your arm and sight down over your thumb. Measure the various heights by moving your thumb up and down on your pencil so you can measure the height in comparison to the width." He illustrated the simple principle on his sketch pad, urging them to do likewise. Then he continued, "In order to determine where our edges will be, we measure from the top of the mountain to the horizon line. Use that as a fixed measurement to compare everything with. Next, measure how wide the mountain material is in comparison to its height. If it turns out, say, three times as wide as high, all you do is divide your baseline into three parts, with one-third of it the height of the mountain. If the horizon isn't obvious to you, select a point horizontally across from your eye and know where it is. The point of view of your picture is chosen around that horizon line. Your choice of horizon line determines whether you're looking up at the mountain or down at the pond, lake, stream or prairie."

He urged them to work with the shapes of the rocks, trees, and ridges, as well as the area devoted to prairie, sky and mountains, in the simplest shapes. After that they made a larger pencil sketch of the area chosen, rearranging the basic shapes in a larger space.

156

At lunch, between bites on sandwiches, students fired questions at

The 3 principal teachers at Teton Artists, Associated, the Jackson Hole art school which flourished for 6 or 7 seasons. Left to right: Grant Hagen, Paul Bransom and Conrad Schwiering.

Instructor Paul Bransom, using whitewash, outlines the anatomical structure of a horse for his students. The gifted artist worked out of a studio in the Bronx Zoological Park during his early years. His illustrations graced hundreds of animal stories in many national magazines. (Photo by Jim Elder.)

the instructor, each of them anxious to be back at his work.

After lunch, they began to translate the shapes on their boards into a workable picture. Each of them had been through three analyses of their subject, so they should have been in scale, with an interesting group of spaces on their boards. The instructors encouraged them to work small, because the more complicated mechanics involved in covering a large board or canvas required more experience.

"We wanted them to finish a day with something they could refer to and say, 'This is a note.' We told them they were going to do a sketch in nature. We were not going to do a masterpiece or a finished painting. We taught them to approach the country, to analyze it, and to proceed on their own. We encouraged the students to return to the area the next day to make drawings of the material they would need when they did a larger painting from their sketch."

By about two o'clock they had analyzed the subject matter and the various shapes, and the mood was beginning to come over the mountains. Armed with the fundamentals they painted vigorously.

The instructor urged them to paint as rapidly as possible, working with the various colors and values of the mood that was happening at the time. Few of them were able to keep with the mood — few landscapists are — but they were learning to remember the salient features and make enough notes so that the painting would come together later.

By four in the afternoon, the students generally had painted a series of sketches, some good, some bad, but everyone had something to show for his time in class. Some of the more diligent students stayed after class and worked until dark.

Connie feels the teaching was good for him. "It forced me to review the basic fundamentals of nature regularly," he says. "When you are forced to explain the basics over and over, they become a part of you even more."

Connie was usually exhausted when he got home after a day being harassed by someone who wanted a critique every two minutes, or by a student who wanted to monopolize the instructor. "Nobody can grow unless he works by himself," he says. "If you let someone else do your planning for you, you aren't thinking for yourself — you're thinking, 'What is *he* thinking, what does my instructor want me to do?' That isn't good teaching. If you don't make the student think independently, but make him in your image like a parrot, you aren't being fair to him or teaching art."

Connie says he wasn't a very kind teacher. Teaching art was no

Schwiering taught his students to work small for accurate scale. This actual size
sketch shows that Schwiering practiced what he taught.

game with him, but serious business. "I'm sure I insisted on too much complete dedication to the work," he says. "I didn't find such dedication very often."

He recalls the crits he got from Chapman and Bridgman, where he used to hide his brushes so they couldn't pick up a brush and show him his failings. "Chapman would say, 'All right, Connie, get out a brush,' when he came up to me. He was brutal in his crits. If you didn't see your mistake, you found out why you didn't see it. Having been trained that way, I worked that way with my students." Connie avoided re-painting their pictures. "There were many who wanted that, too," he recalls. "Usually I illustrated a point by drawing a little painting on their palettes, to give them a point of reference in color and color value."

Connie says the average person thinks of water as being blue, trees in green, grass green. "They don't look with their mind and their eye at the subject and compare the various colors. I think this is from inadequate art instruction in elementary school. The schools don't have time to teach people how to see things."

Teton Artists, Associated, lived a productive life for six or seven summers. Then Paul Bransom became ill and was unable to return to Jackson for classes, and the load was too much for Connie and Grant, so they gave up.

"As I look back on my days as a teacher," recalls Connie, "I remember the time I was with Bert Phillips in Taos — when I was on his back three times a day with a picture. It's pretty hard not to be cooperative when somebody wants to know."

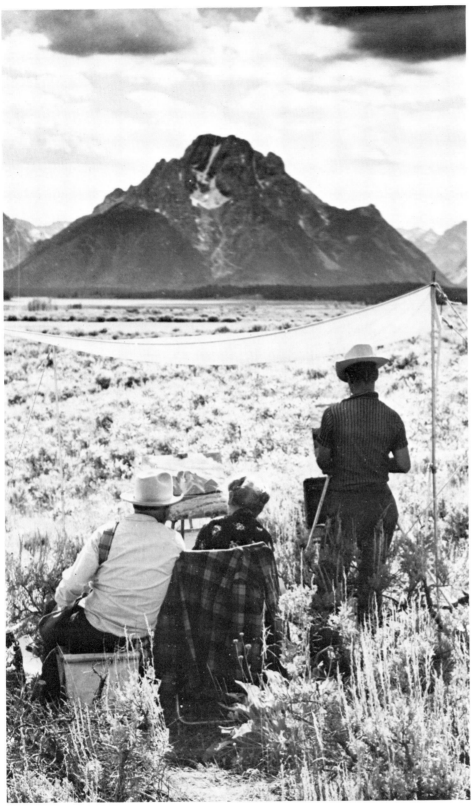

A student's work is discussed in detail, while massive Mount Moran broods in the background. (Photo by Jim Elder.)

CHECKIN' THE DIVIDEND. *Oil on prepared board. 30x36 inches.*
From the collection of Mr. & Mrs. Harold Jungbluth, Wauwatosa,
Wisconsin

162

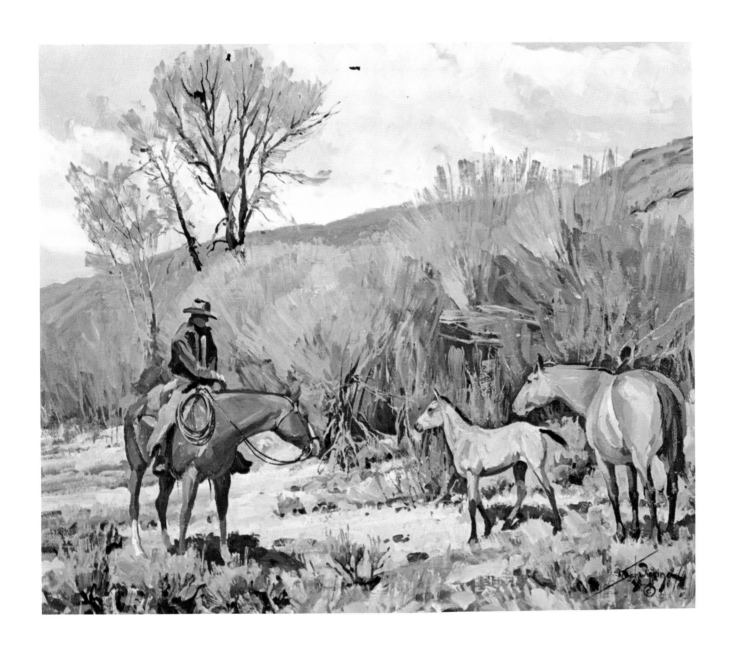

HIGHLAND GOLD. *Oil on prepared board. 30x36 inches, Denver, Colorado. (A reproduction of this painting was sent out in 1965 by Palmer Hoyt, Editor and Publisher of the DENVER POST, as Christmas Greetings to several thousand prominent people throughout the United States.)*

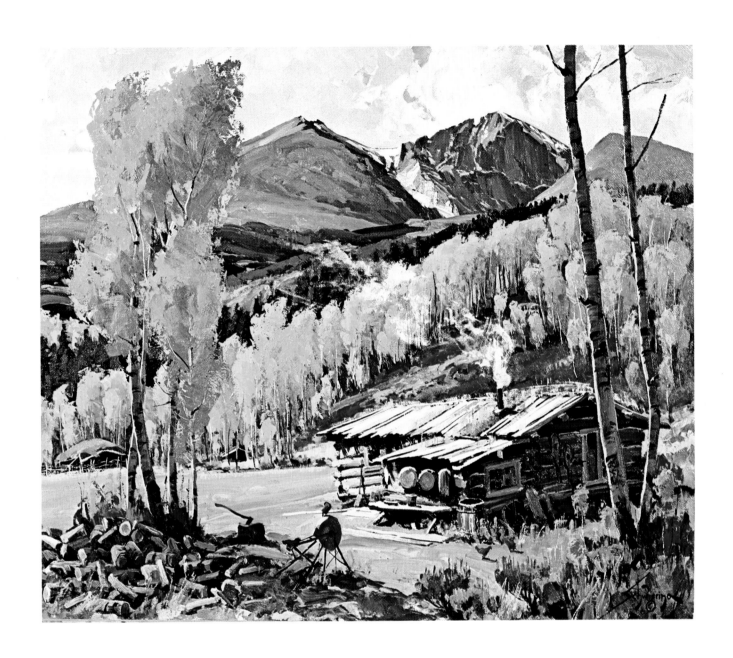

WHEN A FELLER NEEDS A FRIEND. *Oil on prepared board. 30x40 inches. From the collection of Mr. & Mrs. Gerald D. Wilson Pasadena, California*

168 MT. MORAN, *Oil on prepared board. 36x60 inches. From the collection of Mrs. Conrad Schwiering, Jackson, Wyoming*

"In the Prime" 30"x36" oil on prepared board

CHAPTER
EIGHT

INTO THE LAST FRONTIER

You'll find the last American frontier in southeastern Utah. Deep multi-hued gorges and awesome stone monoliths challenge the limits of imagination, and you can walk in the footprints of dinosaurs and call a quarter-million acres your own. Few artists had been able to capture the majesty of Canyonlands on canvas. An official of the Utah Travel Commission thought Connie Schwiering might be equal to the task. Jerry Pulsipher called Connie one day in July, 1965, with a proposition. Connie invited him to his studio.

"I've watched your work for quite awhile," said Pulsipher, "and I'd like to interest you in coming into southern Utah sand rock country to paint."

Connie was intrigued with the idea. He grew up loving the red rock country around Laramie and painted many pictures of it. "I can give about two weeks after the fall color is gone up here," he told Pulsipher, "but I don't want to go to paint. I just want to look at the country." Pulsipher agreed to organize a trip through the Canyonlands for the artist.

When he was satisfied that he had collected enough statements of the Teton fall, Connie and Mary drove to Grand Junction, Colorado. Pulsipher met them and they drove to Moab, Utah. Pulsipher introduced them to Mitch Williams, in charge of Tagalong Tours of Moab.

Because there weren't any roads, they drove up dry creek beds over bone-jarring rocks. Metal plates on the underside of the four-wheel

drive jeep protected the crankcase and running gear, and the specially built carburetor kept the engine from stalling on the steep hills.

Mitch took them into the Angel Arch area, undoubtedly the symbol of the Canyonlands. The arch's opening measures 190 feet from bottom to top, and it resembles an angel carved out of sandstone. The trip took them an entire day to get to the arch and return, even though it's only 12 miles from park headquarters.

Afterward, they drove through the Blue Mountains, then traveled through the Natural Bridges Monument and along the White Canyon. They crossed the Colorado River on the ferry at Hite, drove up through the water pocket fold, then went to Page to see the Rainbow Bridge National Monument. They ended up in Salt Lake City, after driving through Zion and Bryce Canyon.

The weather was warm and the scenery resembled fall in the best part of Wyoming. The cottonwood trees wore golden leaves and the underbrush had turned. High on the mountain slopes the aspen had already lost their leaves. Connie made some drawings and the trip whetted his desire to get back in that country and work.

Canyonlands developers are intensely proud of their country. They feel that they sit in the heart of an undiscovered scenic wonderland still inaccessible to the average American. Connie gathered his sketches and told Pulsipher he'd be back the following year.

During the next winter, Holly Leek found out Connie was going into the Canyonlands and asked if he could go along to take care of his camp. Connie quickly agreed.

Steve Leek came to Jackson Hole in 1888, followed soon after by his half-brothers, Charles and Ham Wort. All sought to carve a piece of America for themselves. The Leeks had a boy they called Holly, because he was born at Christmastime. When Connie met Holly, he was a renowned guide and hunter. Sundays, in the winter, after Holly had fished through the ice on Jackson Lake, he posed for Connie.

Holly had been in the dude business since he was a boy. Connie describes him as "everything that was the West." He and his wife, Oral, ran the Leek's camp at Jackson Lake for many years. Each fall Holly had a hunting camp full of important people who appreciated his skill as a packer and guide.

The two couples traveled to Moab, Utah, on October 30, 1966. The men bought provisions while the women settled in at the motel.

Mitch Williams picked up Connie and Holly the next morning and they headed for Angel Arch in Williams' air-conditioned International.

"Enjoy this now, while you can," said Holly after awhile, "because it won't be long til they build a road right up here."

Mitch Williams loved every rock and crevice in that country. He felt it would be sacrilege to open the country to general traffic. Such "progress" would forever rob the country of its romance and charm, depleting the last vestiges of natural wildness that had become such a part of him. Mitch left the men in the vicinity of Angel Arch and headed back to civilization.

While Connie worked on his pictures during the next dozen days, Holly searched every possible Indian campsite for miles around. His curiosity took him into obscure canyons, over ancient ledges, where bits of pottery and petrified corn lay about, messages from the Anasazi — the ancient ones. Then at night around the campfire, his "poking stick" in hand, Holly spun yarns of the good old days, when he was a child accompanying his father on hunting trips into the mysterious Yellowstone Park — how they loaded wagons in preparation for month-long treks into the wilderness. While he talked, pipe clenched between his teeth, Holly scratched in the fire with his cane, the old root that he had found and notched as each day passed. His stick moved constantly, and as he talked he could lean over and push a log back into the fire, without losing the rhythm of his tale.

The first few days, Connie scrambled over the rocks near Angel Arch. He made drawings and noted possible compositions. His finished painting shows the arch in the mid-morning light, the wing-like fins against a background of clear morning sky. Mitch told him, "At sunrise, when the light is right, the arch is pure gold." The phenomenon occurred twice while they were there.

Mitch returned after about a dozen days and took them back to Moab. They spent a day cleaning up, then hit the road again. This time their destination was Rainbow Bridge National Monument. The world's largest natural bridge, the great arch spans a tributary of the Colorado River. Holly set up camp again, and Connie spent the first few days sketching. Their solitude was interrupted by tourists who came up the Colorado by boat and walked a mile to the bridge. They looked, ate their lunches, then headed back, leaving the bridge to Connie and Holly — and the ravens.

The solitude was refreshing. Their only contact with civilization was the airplane trails they saw as they looked upward through the slits in the rock canyons. Connie says, "The planes would come, and Holly would say, 'There's the 7:15 for Las Vegas.'"

The best, most dramatic lighting on Rainbow Bridge came in the late morning or early afternoon, when the sunlight illuminated the

underside of the great arch. Connie says, "It gave me the feeling of a pot of gold at the bottom of a rainbow." He sketched for two days.

To Connie, one basic analysis of the subject matter is necessary to become familiar with the country. Otherwise, he says, "you're like the duck hunter who shoots at the flock hoping to hit a duck. I approach an area slowly and methodically, so I can get hold of it."

Connie could envision many years of study in the Canyonlands. "One day," he says, "someone is going to make a life's work painting that material. It takes someone who has the desire, the time and the age to really become a part of it."

When bad weather kept Connie from painting, Holly suggested a course of exploration and the two of them spent the day in search of other hidden treasures in the canyon. Then they sat by the fire and listened to Aztec Creek and talked, while Holly kept the fire stirred with his notched walking stick.

Connie finished his painting and they joined their wives again. Before they left for Jackson, the Travel Commission asked him to leave his paintings for exhibition.

A year passed and Connie and Holly returned to the Canyonlands, leaving their spouses in Jackson. Mitch Williams took them into the Chesler Park area.

Chesler Park, a perfect bowl surrounded by high tentacles of rock, is about a mile wide and has variegated stripings of pinkish and white rock. Connie worked on a painting that showed the big, park-like area with one of the fins of rock running through it.

Holly took his cane and notched it again to keep track of the days. He wanted to get over into Virgin Park, less than a half mile from camp. He never made it, though he tried for two or three days to traverse the maze of canyons and rocks.

Holly was amazed that Connie was so interested in his work. He had never been with anyone who got up before he did. He finally realized that Connie had one thing on his mind, painting. When it was painting time and painting weather, Connie painted.

Holly planned for the days when Connie couldn't paint. When the weather turned, Holly suggested a trip and off they'd go in search of adventure.

Connie completed his painting and the duo returned to Jackson. Oral celebrated by preparing a sumptuous western dinner. Later in the winter Holly and Oral invited them back to view slides of the Chesler Park trip.

Sketch of Holly Leek, with his "poking stick," made during trip to Canyonlands, Utah.

After dinner they looked at the slides and Dr. Don MacLeod said he thought Holly and Connie ought to go with him into the area around South Pass City. "Don had been trying to get me down there for a year," says Connie, "and Holly took the bait just like a fish takes to a fly." They agreed that it was the right time to go to South Pass City. Holly said, "I'll take the tent and cooking equipment and everything else, and let's set it up for Wednesday or Thursday of this week." They parted in good spirits.

Holly Leek died the next day from a heart attack. He had cut his last notch.

It was the second tragedy within a week. Connie's friend, Bud Walters, had died only a few days before. The Schwierings were tremendously shaken by the untimely deaths. Connie says the thought, "It's later than you think," hit home, so he decided to do something that had been in the back of his mind for a half-a-dozen years. They left in May, 1968, to see and paint the Oregon coast.

They started at Astoria and followed Highway 101. The magnificent shoreline fired Connie's imagination, and they stopped at every park and turnout. After averaging 30 or 40 miles a day they arrived at Brookings, in southern Oregon.

Connie found the days much different than those in the Grand Tetons. Most mornings were foggy. Sometimes the fog lasted all day, or it rained. "But when a good day comes," he says, "it's really a humdinger."

They returned the following spring, driving directly to Brookings. There the beaches faced south and gave Connie a cross-light effect in the morning and afternoon. Lone Ranch Beach, a crescent flanked by huge rock formations became their headquarters. Connie spent several days crawling over the rocks, drawing and composing. His finished painting showed the tide coming in, the water crashing onto the rocks.

He painted several scenes of the ocean, the fishing docks and the sawmills. The experience opened up a new vista, and Connie plans to return to the Oregon coastline in the years ahead and complete the studies he's just begun.

"Every noble work is at first impossible," said Thomas Carlyle. Connie Schwiering has succeeded in capturing the nobility of the Grand Tetons, the majesty of Utah's Canyonlands — and you are sure he can capture the churning, turbulent coastline of Oregon on canvas. The single dominant factor in the career of Connie Schwiering seems to be the fact that, like other men, he has but a single lifetime in which to do his work.

All you can say is — why?

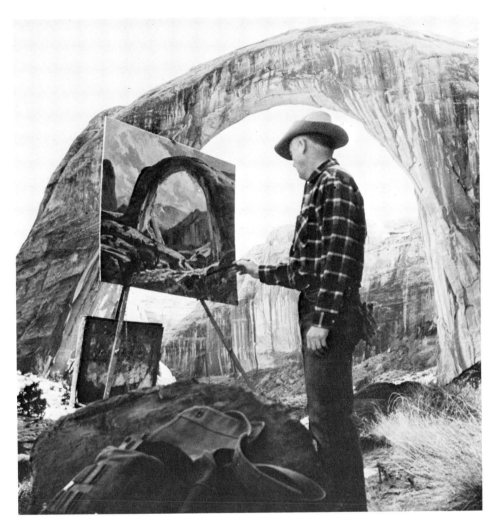

The best, most dramatic lighting, he found, came in the late morning or early afternoon, when the sunlight illuminated the underside of the great arch.

RAINBOW BRIDGE. *Oil on prepared board. 30x36 inches. From the collection of Mrs. Conrad Schwiering, Jackson, Wyoming*

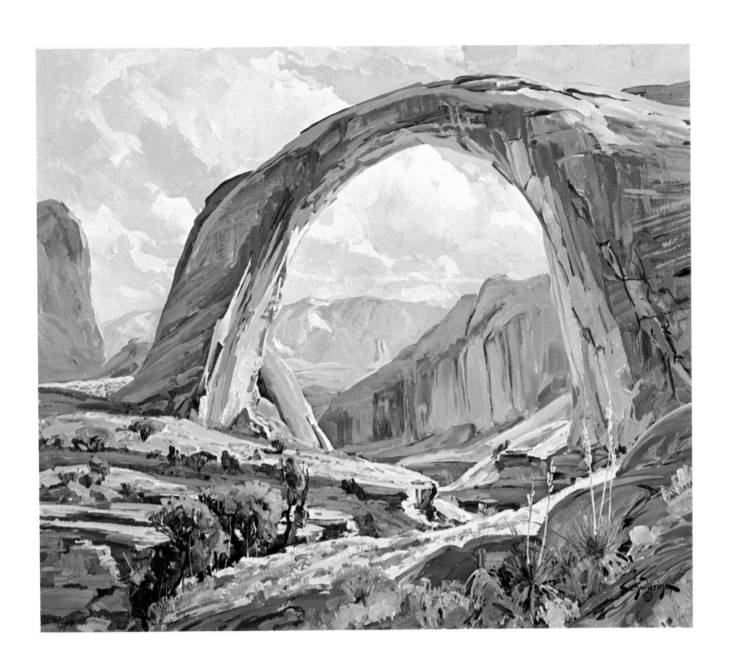

Preliminary sketch for "Sackin' Em Out."

180

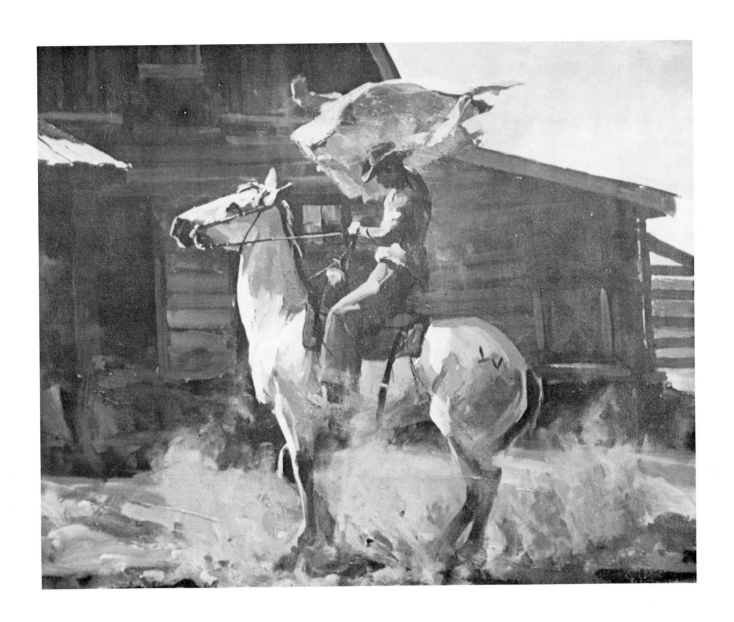

"Sackin' 'Em Out" 30"x40" oil on prepared board

182 RIPTIDE. *Oil on prepared board. 30x36 inches. From the collection of Mr. & Mrs. Eugene B. Sydnor, Jr., Richmond, Virginia*

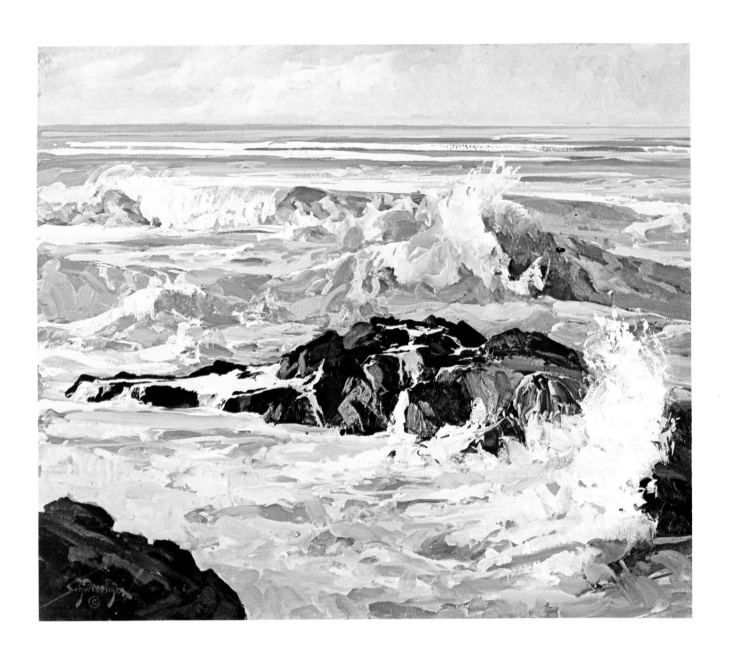

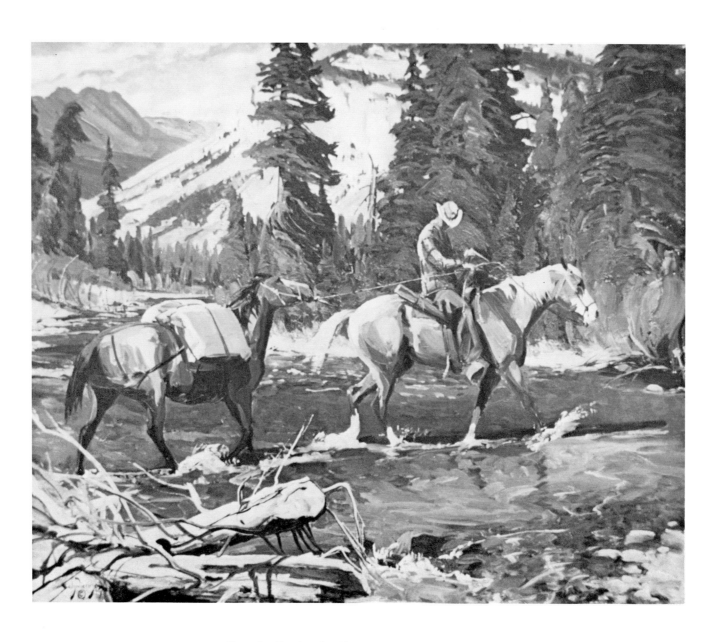

"Favorite Pastime" 30"x36" oil on prepared board

CHAPTER NINE

THE ARTIST AT WORK AND PLAY

I'm sleeping in the guest room on the ground floor when I hear Connie call for me to get up. I raise my head and look between the lumps under the covers that are my feet. Above the top of the four feet of snow outside the picture windows I catch a glimpse of the Tetons bathed in brilliant midwinter sunshine. I pad to the window in my bare feet and part the transparent scrim. The Tetons look arms-length close, just over there across the broad blanket of snow on Antelope Flats. I think blearily, God probably lives here.

Connie's been up since before dawn. He tells me about the beautiful sunrise I missed. I drink my coffee in silence, watching the Clark's Crows and a variety of other birds and animals attack the suet and frozen peanut butter in the feeder outside the south kitchen window. I shiver as I look into the solitude of a nearby grove of trees. Everything outside says cold. I carry my coffee into the living room to get a better view of the Tetons. From the second floor vantage point, the view through the picture windows is like no Cinerama I've ever seen.

I decide that the best way to confront this Majesty is with silence.

"What I want to do," I tell Connie, "is to follow you around today. A lot of people are interested in how a famous artist spends a typical day. I'll keep notes and write one chapter of my book in pseudo-diary form." He agrees to cooperate. I take my coffee into his studio and he follows. I'm curious about the furnishings and other objects he surrounds himself with in his studio.

The rustic wood furniture was crafted by Bill Sargent, who runs

the Rim Station at the top of Hoback Canyon. Bill picks his own lodge pole pine and dries it in his building a long time before making it into solid, comfortable furniture. A beautiful steer hide is draped over the long couch. Connie had picked it up in Denver and had it tanned at Gunther Brothers, well-known taxidermists. The bear hide in his studio was a gift from Red and Belle Mathews. They gave it to Connie when they moved to Colorado upon their retirement from the JY Ranch.

Before the couch sits a marvelous myrtle wood table. They bought that during their first trip to Oregon in 1968. In the north window sits a collection of owl figurines. Lillian Meredith brings a new owl each year. Her husband is buried on the hill above the house, and there is a little shrine dedicated in his memory.

An Appaloosa hide covers Connie's display stand and liquor cabinet. Occasionally Connie brings out his deer and elk hides. They serve a double purpose. He refers to them when painting, "to do a better job interpreting the animal." He doesn't have a moose hide yet, but will some day.

The long table beneath the north window is covered with a stack of sketches, slides, brushes, and books. I examine the books to see what kind of reading the artist prefers. Most of them are related to art and human and animal anatomy.

After awhile Mary Ethel says to come for breakfast and we adjourn to the spacious kitchen.

Later, stepping out into the chilly morning air, I help Connie load the Bronco with his entry in the annual Springville Art Show. As we drive the frosted 20 miles to Jackson, I talk, listen and look. Connie tells me about Perry Wilson.

Wilson worked in the Museum of Natural History when Connie helped Chapman on the Grand Canyon group. Wilson painted the buffalo and grizzly groups in the North American Mammal Hall of the museum.

Because Wilson was proficient in filling big spaces, Chapman leaned on him for information. Painting on the huge walls was like mixing dough for loaves of bread. Each painting required huge volumes of color to prevent mismatching.

In later years Wilson was assigned to paint a diorama of the flying squirrel. Since the flying squirrel is a nocturnal animal, the painting had to be a moonlight picture. Wilson called Connie and asked his help in experimentation with moonlight painting. "This was a real privilege," Connie says. "We studied the moonlight on the mountains for half an hour. Then we turned the studio lights on and painted in the values.

"I was fully awake after about ten seconds outside in the ten-degree morning air." Author on left.

Schwiering loads his entry in the 1969 Springville, Utah, art show. The versatile artist builds his own shipping crates.

Then we'd turn the lights off and study the mountains some more."

The two artists concluded from their study that all the colors are present in a moonlit landscape, "but they are all muted down by the gray, which puts them close together in value."

Connie feels that memory painting is one of the essential facilities an artist must have, "because you're often not able to execute something at the time you see it or experience it." He claims to carry impressions for two or three years, sometimes longer. When conditions are just right, he begins work on a painting that relates to an impression he might have had years before. "I tell Mary Ethel I have so many pictures that I want to paint, I know I'll never have a chance to paint them all, but I'm going to try."

By now we've dropped down into the foggy Jackson Valley, and Connie slows the Bronco to exclaim about the beauty of the frosty trees as they pierce the chill fog. When we're moving again, I ask about his trips into the country around Big Piney, Wyoming.

He tells me he thinks he'll open a door to the past when he paints there. "Two ranches there work with the equipment and philosophy of the past," he says, "the Mickelsons and the Millers, and they don't even go that far back. A hundred years in Wyoming takes you back into a raw western time. Those two ranches put up some hay each year using teams of horses. They are still branding in much the same way they did 50 or more years ago. I hope to paint that before they become completely mechanized."

As the scenery changes from uncluttered countryside to a landscape punctuated with signs and buildings, I begin to realize what he meant when he talked of the land under park control and that on the fringes. The few miles on the north side of Jackson are pretty dismal.

From where we park, just off Jackson's main square, we can see the tiny figures of skiers on the slopes of Snow King Mountain. To and from the post office, I notice that Connie seems to know everyone, and vice versa.

After a day filled with personal visits, a Rotary Meeting and some shopping, Connie and I head home. The shadows are deepening when we pull into Connie's huge parking lot, but there's still time before dinner, and we take a two-mile hike accompanied by the Morleys' two dogs. Connie says he tries to walk every day, and I can tell he's practiced by the brisk pace he keeps. Since there's no traffic on the recently plowed country road, we walk right in the middle of the thickly packed snow. The drifts at either side occasionally reach to our shoulders.

Preliminary sketch for oil painting, "Godfather."

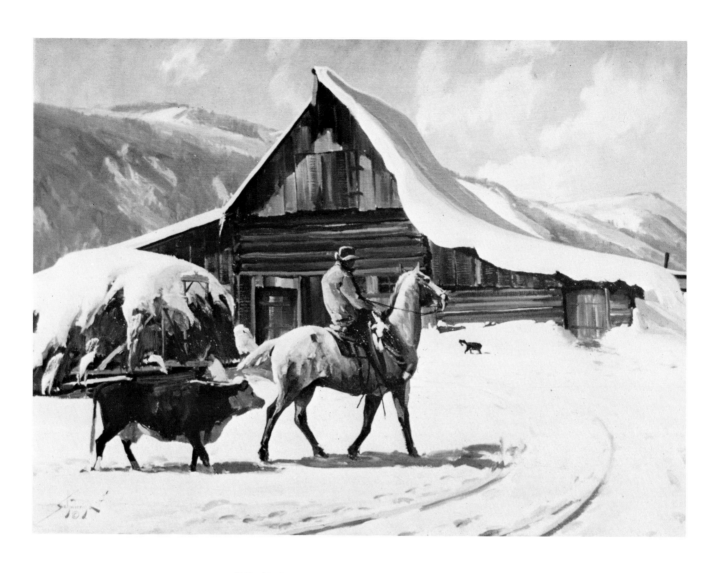

"Godfather" 30"x40" oil on prepared board

Back at the house Mary Ethel has set the table for dinner. Before we sit down, I look again at the vista beyond the picture windows. The house seems to be a ship locked in a stationary sea of snow. I have never experienced such solitude.

At dinner Connie talks about astronaut John Glenn and his family. The Glenns were guests of their friend, Eileen Hunter, the year after Glenn's space flight. Mrs. Hunter brought him over to look at Connie's paintings. The little neighbor boy, Alex Morley, found out about it and came to see him.

"I hear that John Glenn is here," Connie recalls the boy saying. He told him to "come on in." The youth was "completely awe-struck" at meeting the astronaut. As Glenn got ready to leave, Alex slipped away and returned with his new black Labrador pup. When Glenn came out of the house, Alex went up to him and offered him the pup. "This touched Glenn very much," Connie says. "Tears came to his eyes. He explained very carefully to Alex that he would really like to have taken the dog, but he felt the dog was better off staying with him." The humanity of the man was apparent to all of them.

After he had gone, Connie discovered he had written on the bottom of a drawing he made to explain his re-entry problem, "from one great artist to another . . . John Glenn."

Dinner is done and Connie and I sit in the living room. Connie alternately glances at his newspaper and at two of his paintings over the fireplace. A snow scene painted at nearby Blacktail Butte bothers him, he confides, and he may change the shape of a drift. It looks great to me as it is, and I tell him so, but begin to realize what he means when he says an artist is his most severe critic. I ask about the deep snow and how it affects the animals.

"The moose suffer," he explains. "They exist by eating little cottonwood shoots and sticks of willow and quaker branches, "and it's not too nourishing. I don't see how they make it through the winter."

One morning Connie awoke to a rumbling sound outside their ground level bedroom window. He first thought the furnace was acting up. But when he opened the blind on the front bedroom window, a mother moose stood there staring him in the eye. He closed the blind quickly so the animal wouldn't strike back and break the window. "She was just there for shelter and had her baby with her," he says. The mother and calf stayed around for two or three days, browsing on their precious pine trees and bushes. He couldn't scare them away.

It's getting late and there's much to be done tomorrow, so I head for a warm bath and bed downstairs. Before I turn out the light, I think

191

about Connie Schwiering and what, above all else, makes him great. I think about one of Connie's guiding philosophies — if man is to grow, he must brush up against the greatest of minds.

Continually Connie refers to lessons taught him by great minds: Robert Graham, Bert Phillips, Walter Biggs and George Bridgman, his mentors; the Impressionists, his predecessors; but a day never passes that he doesn't mention some principle taught him by the two men who influenced him most, his father and Charles S. Chapman.

To his father he owes his appreciation for nature and fine music, as well as his superior ability to communicate with the spoken word. He owes much of his business acumen to his father, who stubbornly encouraged him to finish college, *then* pursue his career. His father taught him a fundamental appreciation of life in nature. Even after Connie was grown, a working artist living in his dream home, his father insisted he learn the variety of wild flowers that surrounded the home. On his first visit he counted 19 varieties himself and bought a book so they could catalogue them. The fundamentals.

To Charles S. Chapman he owes his ability to be always the artist, always the master. Chapman knew how tough it was for the Schwierings to live in New York City, both financially and emotionally. And he knew how badly Connie needed to become an artist. He knew, too, when Connie was ready, and he didn't hesitate to tell him. "Pay attention to color," he said before Connie left for the West. "See color in everything that you do. Experiment with color. Try to analyze what makes color, because this is going to be your job all your life as an artist . . . to be able to make color vibrate and give the most that it can give in your picture." The fundamentals.

Connie Schwiering is "contemporary" to no one, because throughout his life he has striven to be independent. Proceeding from fundamental principles, he has invented a new art form . . . a "high and independent" Western Impressionism that only his own great mind could encompass.

In the process of brushing up against great minds, he became what he beheld.

192

EPILOGUE

Further honors came to Connie Schwiering in 1970.

During the summer he again exhibited his paintings at the Whitney Gallery of Western Art, in Cody, Wyoming.

In September he presented his first major midwestern show, at the Steel City Bank in Chicago. Another major show followed at the North Shore Savings and Loan Association in Milwaukee.

In October the Whitney Gallery bought his painting, "Ridin' Drag," for its permanent collection. In his letter of notification, Dr. Harold McCracken, director of the Whitney Gallery of Western Art and Buffalo Bill Historical Center said, "I want you to know how very much we appreciate your graciousness in lending the group of paintings which were exhibited during the 1970 season. I know you would be extremely pleased to have heard the many compliments by the many thousands of people who stood in front of your paintings and admired them. This couldn't happen to a nicer guy!"

Then Connie was one of three Wyoming Alumni who received the Distinguished Alumnus award in ceremonies at the University of Wyoming fieldhouse October 23, 1970.

The citation reads, in part: "Because of the great beauty he has created for art lovers in Wyoming and across the nation, and because of his own devotion to Wyoming's beauty, the University of Wyoming Alumni Association presents with great pleasure, the Distinguished Alumnus Award in the Humanities to Conrad Schwiering."

195

RESOLUTIONS OF THE FACULTY OF THE UNIVERSITY OF WYOMING

December 10, 1963

Oscar Conrad Schwiering, member of the faculty of the College of Education of the University of Wyoming from 1925 to 1954, died at his home in Burbank, California, on August 23, 1963.

Born in Peoria, Illinois, on September 5, 1886, he earned the A.B. degree at Iowa Wesleyan College in 1909; his M.A. from the University of Wyoming in 1916; and his Ph.D. from New York University in 1932. He did post-doctoral work at Columbia Teachers College in the fall of 1943.

Dean Schwiering devoted his life to the cause of education. He was a college teacher at Berea, Kentucky; principal at Marengo High School in Illinois; principal of Cheyenne High School from 1912 to 1916; superintendent of schools at Douglas, Wyoming, from 1916 to 1919, and at Rock Springs, Wyoming, from 1919 to 1925. He joined the faculty of the College of Education in 1925 as Professor of Education and Director of Student Welfare at the University of Wyoming. In the fall of 1939, he was promoted to the position of Dean of the College of Education and Director of the Summer School. He was Dean until July 1, 1954, when he became Dean Emeritus.

Dr. Schwiering was Dean of the College of Education during the planning, construction, and occupancy of Education Hall, a building whose cornerstone was laid in 1948 and which was dedicated in 1949.

Dean Schwiering's service to education did not end upon his retirement at the University of Wyoming. In connection with the University of Washington he served for two years as Educational Consultant in Pakistan. Upon his return to the United States, he accepted a position at California State College in Los Angeles.

After his retirement from professional life, he pursued with considerable success his hobby as an amateur artist. In fact, he held successful art shows of his own in California.

Among the honors conferred upon Dr. Oscar Schwiering were membership in Kappa Delta Pi and Phi Delta Kappa; the presidency of the Wyoming Education Association; and membership in Who's Who in America. He contributed articles to several national magazines. He was chairman of a group of educators who devised the Wyoming Cumulative-Record Card for elementary and secondary schools.

Many members of the teaching profession in Wyoming and in other states owe much of their success to their association with the late dean.

Dean Schwiering is survived by his wife, Willetta, and by two sons: Oscar Conrad, who is an artist at Jackson, Wyoming; and William Henry, who teaches in California.

Be it resolved, therefore, that this faculty hereby expresses its sense of great loss at the passing of Dean Oscar Conrad Schwiering. Be it further resolved that the faculty extend its deepest sympathy to his family and that copies of this resolution be spread upon the minutes of this faculty and also be transmitted to Mrs. Schwiering and her two sons.

CITATION — Conrad Schwiering

Because of the great beauty he has created for art lovers in Wyoming and across the nation, and because of his own devotion to Wyoming's beauty, the University of Wyoming Alumni Ass'n. presents with great pleasure, the Distinguished Alumnus Award in the Humanities to Conrad Schwiering.

Mr. Schwiering, one of the country's most successful western artists grew up in Laramie, where his father, Dr. O. C. Schwiering was Dean of the College of Education. He received his degree from the University of Wyoming in 1938. From 1939 until his military service in 1941, he studied at the Art Students League and the Grand Central School of Art in New York City.

Connie and his wife, the former Mary Ethel Smith, a University of Wyoming graduate with the class of 1937, moved back to Wyoming and chose Jackson Hole as the ideal spot for an artist to take up residence, in the spring of 1947. They began building a home and studio on a knoll near Antelope Flats eight miles from the Grand Tetons with one of the most magnificent views in the world.

Connie has had many one-man shows throughout the United States, and this year has been an exceptional one. Dr. Harold McCracken, Director of the Whitney Gallery of Western Art in Cody, has displayed for the second time, a group of five paintings in the western museum. This artist has been invited to show at the Gilcrease Institute in Tulsa, Oklahoma, and in Chicago. His works are handled primarily by the Grand Central Art Galleries in New York City, and the Biltmore Galleries in Los Angeles.

In 1968 Connie was named "Man of the Year in the Arts" by his fraternity, Sigma Nu, at their national conclave.

The artist belongs to the American Insititue of Fine Arts; the Society of Western Artists; and the Wyoming Artists Ass'n. He is serving on the Wyoming State Art Gallery Council and the Grand Teton Natural History Ass'n, and is a member of the Wyoming State Historical Society.

As a fraternity brother in Sigma Nu, and a long-time friend, it gives me great pleasure, to present this Distinguished Alumnus Award to Wyoming's outstanding artist, Connie Schwiering.

October 23, 1970
Jack Guthrie, President
University of Wyoming Alumni Association

EPILOGUE Milestones

1916 Born, August 8, in Boulder, Colorado

1934 Graduated from Laramie High School, Laramie, Wyoming

1938 Graduated from University of Wyoming, BA, Commerce & Law, minor in art

1934-39 Study with Robert Graham, Denver, Colorado

1936-39 Study with Raphael Lillywhite, Denver, Colorado

1938 Study with Bert Phillips, Taos, New Mexico

1939 Married September 1 to Mary Ethel Smith, Laramie

1939-41 Study at Art Students League, New York City
Study at Grand Central School of Art, New York City, awarded Medal of Merit
Study with George B. Bridgman, Charles S. Chapman, N.A., and Walter Biggs

1941-46 United States Army Service, discharged Lt. Col.

1947 June, arrived in Jackson, Wyoming
First painting sold in Jackson, a 12x16 called "Fence Mender"

1951 November 27, elected member of Grand Central Galleries, New York City

1952 June, elected member of Salmagundi Club

1956 Death of Charles Dibble

1958 Home completed

1962 Death of Charles S. Chapman

1963 Death of father, O. Conrad Schwiering

1964 Show at First National Bank, Laramie

1965 Death of mother, Willetta Schwiering

1965 June, show at Whitney Gallery of Western Art, Cody, Wyoming

1966 Television documentary, KTWO TV, Casper, Wyoming

1968 Death of Holly Leek

1968 January, elected member of Biltmore Galleries, Los Angeles

1968 August, chosen "Man of the Year in the Arts," by Sigma Nu

1970 June, show at Whitney Gallery of Western Art, Cody, Wyoming
September, first major midwestern show in Chicago
October, Whitney Gallery purchased painting for permanent collection
October, Distinguished Alumnus Award from U. of Wyo.

ACKNOWLEDGEMENTS

To the people who have been my motivation, my consolation, my companions, my friends — please accept my heartfelt thanks.

Oscar and Willetta Schwiering, parents
Charles Chapman, artist and mentor
William Schwiering, brother

Alphabetically:
Slim Bassett, rancher, "Slim the Guide"
Walter Biggs, artist
Cyrus Boutwell, owner, Boutwell Galleries
Paul Bransom, artist and colleague
George Bridgman, artist
J. Marius Christensen, owner of The City Market.
Truman E. Clark, Cocks-Clark Engraving Co.
Gerard Curtis Delano, artist, DENVER POST
George A. Dick, bought Schwiering's first painting
Charles A. Dibble, forest ranger
Robert Graham, artist
Grant Hagen, artist and colleague
Cliff and Martha Hansen, rancher, Senator
Palmer Hoyt, publisher, DENVER POST
Cleo Karns, former landlord
Holly Leek, guide and hunter
Raphael Lillywhite, artist
Gene Lindberg, writer, DENVER POST
Dr. Harold McCracken, director, Whitney Gallery of Western Art
Alexis McKinney, Denver, Rio Grande
George Mackin, painter, contractor
Ray Malody, rancher
Dr. Donald MacLeod, doctor, Jackson
Wes and Virginia Marks, Valley Shop, Jackson
Red Mathews, JY Ranch foreman, "Horse Talk"
Lillian Meredith, good friend
Frank Moore, store owner, Jackson
Alex Morley, neighbor and builder
Dr. Floyd and Gladys Naegeli, Dentist, Jackson
Bert Phillips, artist
Jerry Pulsipher, Utah Travel Commission
Don Redfearn, Elk Refuge, Director
John D. Rockefeller, Jr.
Jack Ruch, brother-in-law
Bill Sargent, Rim Station, Jackson

Milward L. Simpson, lawyer, former Governor and Senator
Gladys Smith, good friend
Joe Tomich, motel owner and builder
John and Louise Turner, Triangle X Ranch
Reed and Helen Turner, Turpin Meadow Ranch
Bud Walters, good friend
Helen West, Teton Artists Assoc., class monitor for Teton Artists
 Associated
Bates Williams, superintendent, Canyonlands National Park
Mitch Williams, Tagalong Tours
Perry Wilson, artist
Paul Wise, contractor

 Conrad Schwiering

INDEX

(Because references to them occur so frequently in the book, the town of Jackson Hole, Wyoming, and the names Conrad and Mary Ethel Schwiering have been excluded from this index.)

COLOPHON

This book was lithographed in Aberdeen, South Dakota, by North Plains Press. Headlines were set in *Optima* and the text matter in *Times Roman. Leslie Paper Company* supplied the paper, 80-pound *Mountie Matte*. Color separations were supplied by *Mueller Color Plate Company* and the book was bound by *A. J. Dahl Company* of Minneapolis, Minnesota. Cover design and book lay-out was conceived by the art staff of North Plains Press.